# Strengthening Emotional Ties through Parent–Child-Dyad Art Therapy

# Strengthening Emotional Ties through Parent–Child-Dyad Art Therapy

## Interventions with Infants and Preschoolers

*Lucille Proulx*

*Forewords by Lee Tidmarsh and Joyce Canfield*

Jessica Kingsley Publishers
London and Philadelphia

First published in the United Kingdom in 2003
by Jessica Kingsley Publishers
116 Pentonville Road
London N1 9JB, UK
and
400 Market Street, Suite 400
Philadelphia, PA 19106, USA
*www.jkp.com*

Copyright © Lucille Proulx 2003
Printed digitally since 2005

**Library of Congress Cataloging in Publication Data**
A CIP catalog record for this book is available from the Library of Congress

**British Library Cataloguing in Publication Data**

Proulx, Lucille, 1932-
   Strengthening emotional ties through parent-child-dyad art therapy : interventions with infants and preschoolers / Lucille Proulx.
      p. cm.
   Includes bibliographical references and index.
ISBN 1-84310-713-9 (alk. paper)
1. Art therapy for children. 2. Family psychotherapy. 3. Arts--Therapeutic use. 4. Child development. 5. Child psychiatry. I. Title.

RJ505.A7 P76 2002
618.92'891656--dc21                                          2002027526

ISBN-13: 978 1 84310 713 2
ISBN-10: 1 84310 713 9

# Contents

## List of Figures

*I dedicate this book to the parents and children that have experienced dyad
art therapy and in doing so have enriched my life
Particular thanks to the group who gave me this going away poem:*

For all the days of goop and paint,
You taught us how to play
To help our caged birds find
Their freedom.

# Foreword

Work with infants and toddlers and their parents has been a relatively new phenomenon in the field of mental health. Over the past 30 years, psychiatrists and psychologists have turned their attention to infants, developing clinical tools to identify problems accurately, and researching theoretical constructs such as 'attachment.' Associations are now in place such as the World Association for Infant Mental Health, and the International Center for Infant Studies, to promote research and clinical work with infants and families.

The study of infants spans many professions adding to the richness of this field. One cannot understand babies without some knowledge of development in the areas of motor function, language, and socialization. Nor can we begin our work unless we have an understanding of the temperament, including the self-regulation capacities of the infant in question. Finally, we have to be aware of the environmental influences on the baby, from the relationship with the primary caregiver to outside factors far from the baby, such as the health of the economy affecting the employment and financial situation of the family. In learning about all these factors, one crosses paths with many professionals who can add information and provide support for the rearing of that child.

Art therapy is one such profession that has turned the spotlight onto infants. I had the privilege of working alongside Lucille Proulx as she developed her creative ideas to promote better interaction between infants and their parents. Until Lucille came along, infant-parent psychotherapy consisted of unstructured play between the parent and infant, and discussion between the parent and therapist. It became apparent as she developed her ideas, that she was one of a handful of people in North America who knew how to use hands-on type of activities to work with very young children. There was much interest at

conferences where she presented her work, since she could give therapists concrete suggestions about what materials and activities to use, and then discuss the goal and meaning of the ensuing behaviors between the parent and child. By linking the art activities to theoretical ideas emerging in the field of infant mental health, she created a model for others to try out and eventually research and modify.

Lucille has written down her ideas and provided the reader with excellent instructions to try out her method. She provided much pleasure and learning for the parents and infants she worked with in our clinic. I hope she provides you, the reader, with an equal amount.

*Lee Tidmarsh MDCM FRCPC*
*March 2002*
Child Psychiatrist
Director, Family Infant Clinic
McGill University Hospital Center
Montreal

# Foreword

Early childhood intervention has become an important focus for communities, health care institutions, educational systems, and government. Programs have targeted environmental and social issues. Emphasis has often been on educational needs and cognitive development. Only recently has the emotional development of the infant and child become a focus for study and intervention. The important interconnections between environment and development are summed up in the expression of D. W. Winnicott: 'there is no such thing as a baby' pointing out the need for a caretaker not only for survival but for ongoing development of the infant.

In this book Lucille Proulx focuses on this earliest relationship. From her lengthy experience as parent, community worker, and art therapist, she has evolved an exciting and creative approach to working with parents and young children. Along with discussing the theoretical background of her work, she shares her clinical experience and years of practical wisdom.

It has been a great pleasure to have participated in some of the work portrayed in this book and to have written this foreword.

*Joyce Canfield MD*
*March 2002*
Child Psychiatrist
Director, Preschool Day Treatment Center
McGill University Hospital Center
Montreal

# Acknowledgements

I wish to thank all those who unknowingly contributed to my writing this book, the children, and the parents who participated in the dyad art therapy experience. I wish to show my appreciation to my colleagues on the Family Infant Team and those on the Preschool Day Treatment Center team. I recognize the encouragement I received in putting this method into practice, and the opportunities, which were afforded me to present my work at conferences and workshops in the field. I express my gratitude to Dr Joyce Canfield, director of the Preschool Day Treatment Center, who recognized my potential and invited me to join the team 15 years ago and to Dr Lee Tidmarsh, director of the Family Infant team, who also provided me with several opportunities to present my work with infants in Montreal and in Washington DC. My added thanks to both very busy professionals for writing the forewords for the book.

Sincere thanks to Dr Klaus Minde, the former director of child psychiatry at the Montreal Children's Hospital, who co-lead the first father–child group and who encouraged me to write and publish my first article on the experience. My appreciation to: Rhona Bezonsky, social worker, who invited me to do art therapy with the parents and children in her divorced parents' group. Thank you to Audrey Lowitz with whom the Parent/Child Interaction Group was formed and co-lead; to my colleague, psycho educator and infant specialist Donna Casa-Martin with whom the pilot project for the Day Treatment Center was formulated; to Lindsey Aspler, and Jennifer Hooper, child specialists who co-lead the groups with me; to Richard Bass, psychologist, kindergarten special educator who assisted in setting up the kindergarten group, co-lead the art therapy and parents' group and shared this mutual experience. Thanks to social worker Nora Alexanian who always had time to hear my concerns, and co-ordinator Linda Vaupshas for her encouragement.

I also wish to thank Concordia University's Art Therapy Program, for the art therapy interns under my supervision, that permitted me to articulate the work. Un grand merci to Dr Pierre Gregoire, psychologist at the Allan Memorial Institute and professor of Art Therapy at Concordia University in Montreal. He has been my mentor and thesis supervisor. I would also like to thank Linda Chapman, an art therapist who works at the University of California's San Francisco Injury Center who, after attending one of my workshops, has supported my work consistently.

I want to mention all those who worked relentlessly with me to get this information in book form, in particular: my daughter Victo Jodoin, artist; also my friends Siri Jarrett, literature teacher; Alfred Walsh, English and psychology major; Monica Carpendale, art therapist, and director of the Kutenai Art Therapy Institute; and thanks to Kim Cooney, art therapist, for the final proof reading. My friends and my children who are always there to support my many projects. And to my grandchildren who keep me in touch with the pleasures and woes of growing up.

I refer extensively to Dr Stanley I. Greenspan and I recommend his books to therapists wishing to work with the infant and preschool population. His work on the functional emotional stages of development of the child, and his intervention floor time, have inspired me, and have given me the tools necessary to formulate the work that I do with children and parents. I have made special reference to the work of D.W. Winnicott, and to Arthur Robbins, to impress on the art therapists the dynamics of the work and I recommend that their books be referred to by those working in this field.

Special thanks to Jasmine Jodoin for the cover drawing and thanks to Quade and Mum who permitted me to include them in the book, while in the process of doing dyad art. Thanks also to the young artists and their parents who contributed the artwork in the book.

Finally, yet importantly, I would like to thank Jessica Kingsley Publishers, and Jo Gammie and Vicky Read for their understanding and assistance. I appreciate the opportunity which you have given me to increase the body of knowledge in art therapy thus encouraging me to pursue this uncharted territory of parent–child-dyad art therapy.

# Introduction

In 1975, I began working in the community with parents at the Ottawa Twins' Parents' Association (OTPA). As a mother of eight children ranging in age from infants to 22 years, I found that my experience and practical parenting knowledge were a benefit to many new parents. Through my participation with twins' parents' groups at local and national levels, I attended many conferences and became familiar with professionals in the social fields. I trained with the Family Enrichment Association and the Adlerian Center to become a parenting course leader. I wrote books on toilet training and on communicating more effectively with twin babies, and compiled a guide for Practical Effective Parenting (PEP) courses. I presented at conferences for parents as well as for professionals. My many years as an at home mother became valued. As a home day care provider, I gained hands-on experience with the difficulties parents had understanding their children, and with difficulties children had relating to their parents.

These valuable experiences together with my parallel ongoing studies of psychology and fine arts at university, led me to seek employment at the Parents' Preschool Resource Center (PPRC) in Ottawa, where parent and child workshops were being presented. My position at the PPRC as Francophone Outreach Coordinator (Animatrice Communautaire Francophone) included supporting preschool playgroups in the community and animating whole day preschool activities with parent and child at outdoor festivals and workshops. It was at this time that I began developing activities that parent and child would do together; this led me to education and training as an art therapist. When I began my

clinical experience as an art therapy intern in the Preschool Day Treatment Center at the Montreal Children's Hospital, my focus was working with parents who had sought psychiatric services for their children. The psychological pain connected to parents taking such a step was a major part of the work at the clinic. The anxieties the parents expressed when their child was going into therapy were at times expressed as fear, anger, envy, and often confusion. Helping parents through the challenges of raising children has occupied a major part of my adult life. I hope this book will contribute.

## Objectives of the book

Parent–child-dyad art therapy has evolved in the child psychiatry field, working with parents of infants and preschool children. The goal of this book is to familiarize art therapists and mental health professionals intervening with these populations, to the theories and research behind the therapy. It may also be of interest to concerned parents. This parent–child-dyad intervention is a therapeutic modality based on certain principles from the fields of child psychiatry, psychology, and art therapy. This intervention proposes a creative, imaginative, visually oriented experience for both the parent and the child, and comprises non-verbal and symbolic self-expression. The art therapy process unfolds in the context of two therapeutic relationships in which the creation of images is the primary mode of communication. The two therapeutic relationships are the relationship between the dyad and the therapist, and the relationship between the parent and the child. The art therapist provides the environment for spontaneous non-verbal self-expression, and facilitates self-expression and communication for the alleviation of emotional stress. Artistic activity such as painting or sculpting, gives concrete expression to both conscious and unconscious elements within the dyad, which act as a therapeutic agent for the unresolved conflicts of both the parent and the child, through which attachment may be strengthened.

Infant psychiatry has developed from a new body of scientific knowledge. Its concepts lie in the importance of interactions between mother and infant during the first three years of life. Taking into

consideration that researchers now feel that the infant from birth is an active participant in environmental life and, for better or worse, a modifier of that environment, focus is now placed on the infant, and the mother–child pair. The infant's creative activity, the quality of care taking, temperament, maternal attitude, environment, and family dynamics all must be taken into consideration (Stern 1978; Brazelton *et al.* 1974). This is also confirmed by David Wesner who states that 'the new orientation to intervention requires that mothers and infants interact not only with each other but also with a third party who is cognizant of the principles of infant psychiatry' (1982, p.309).

I have adapted child psychiatry research and theories with art therapy principles and concepts and have included the use of both traditional and non-traditional art materials in the creation of developmentally appropriate parent–child-dyad activities in order to develop the constructs of the intervention. I will demonstrate how the use of non-traditional art materials, or household materials in art making help the parent in overcoming their inhibitions through free art expression. This freedom from inhibitions allows the parent to tap into memories, unconscious fears, wishes and fantasies, and through the symbolic language of art making resolve early conflicts that interfere with the parent–child relationship. The parent is then able to begin to interact in a playful and imaginative manner with the child. During this process of art making, the parent is asked to follow the developmental abilities of the child, thus the parent feels less threatened at having to produce a work of art. The individual dyad session becomes a transitional space and the group becomes a safe community as well. The parents begin to feel like 'good-enough parents' (Winnicott 1951).

At each session the art materials are set up in an inviting, banquet-like manner. The materials speak for themselves and only a short, clear directive need be given. The therapist is able to discover in only a few sessions the relationship difficulties that arise between parent and child. The methods, media, and ground (the ground is the paper, etc. on which the art is made) all have symbolic content as well as their own therapeutic agenda and assist the parent in following at the age appropriate level for the child's developmental functioning. Art therapist H. Landgarten (1981) refers to the importance of the therapist's competence, and the

need for her to acquire a cognitive perspective on the art materials, directives and process. The symbolic aspect of the activities and media used in dyad art therapy is important in forming the missing bond between parent and child. The activities consist of creating a symbolic container in order to allow the parent and the child to recapture the unresolved core processes of attachment. Paradoxically, the parent becomes the child's therapist, the child becomes the parent's therapist, and the art therapist becomes the facilitator. This intervention brings about change in both the child and the parent's interactions without the dyad being aware that they are changing their relationship patterns. Verbal interpretations are kept to a minimum.

The tactile art activities described in Chapter 5 serve as a framework in which the new interactive roles can be established. The metaphoric work and rituals are effective ways to form new mental representations for each member of the dyad. I have devoted a full chapter to the role of the therapist and the uses and effects of transference and counter transference. Appendix A describes assessments and tests that are frequently used when working with this population. Appendix B includes lists of the dyad art therapy intervention materials and presentations that may help the art therapist to construct his/her own interventions.

This book may be of interest to mental health professionals and parents as well as to art therapists. It is meant to deepen the understanding of this therapeutic modality and to describe the process of art therapy. The book articulates how making spontaneous art allows the release of tension and the projection of repressed materials may help non-art therapists and the parents to request these services, or refer to an art therapist in a variety of cases where non-verbal, creative art expression will be beneficial. The infants and preschoolers that I have worked with and who benefited from this intervention, were children with identified relationship problems, developmental delays, aggressive behaviors, attention disorders and sensory motor problems. Also, children and parents who have suffered separations for many reasons, such as illness of the child or parent; postpartum depression; depression; divorce; trauma or placement in foster homes, to name but a few. In my clinical work, I have not worked in dyads with children who had severe pervasive development disorders.

In the groups there often were children with autistic features who progressed well in dyad art therapy. Furthermore, I have supervized art therapists in the field who are working with children with these disorders and some of the therapeutic activities included here have been modified to intervene with this population. We must be prepared at times to experience failures in this work. It may happen that the parents are so preoccupied with their own issues that they are not ready to work on their relationship with their child. At times individual work is recommended for the parents, as well as dyad art therapy. When the parents for any number of reasons are unable to engage in the work with their child, it may be that this is not the intervention required for therapy.

Chapter 5 describes and lists 30 different therapeutic activities that parents can do with their child and in this manner, they can provide some additional quality time in their interactions. Finally, the main objective of this book is to record and teach dyad art therapy to art therapists interested in working in the prevention field with the early childhood population. It is hoped that this book will make a valuable contribution to the field of art therapy.

Please note that, for the sake of ease, when talking in general terms I have referred to all therapists as 'she' and all clients as 'he'.

# Clinical Issues in Parent–Child-Dyad Art Therapy

## The psychological framework

Numerous researchers have devoted their time and energies to the concept of 'attachment.' Therefore, I will attempt to give professionals in the field of mental health only a succinct review of attachment theories and their progression. In a review of Freud's insights by Dr Everett Waters, we are informed that Freud speaks of mental representations formed during attachment and that these are never voluntarily or completely given up and that they establish a compulsion to repeat past experiences (1999). Waters informs us that Dr J. Bowlby (1969), a pioneer researcher in the field, brought forth the concepts of 'mental-representation' and of the 'secure-base' as well as the innate biological function of the physical presence of the caregiver that brings feelings of security. The concepts are important findings which form the basis for parent–child-dyad art therapy. Margaret Ainsworth (1978) took Bowlby's work to another level, with the 'strange situation' research paradigm. She described the child's feelings upon reunion with the mother after experiencing a stranger in his environment as: secure, insecure resistant, insecure avoidant. By putting the child in such a scenario, we can now evaluate the child's attachment category. It also shows the sensitivity, cooperation, and availability of the mother and her communication skills with her child. These are some of the important foundations for parent–child-dyad art therapy that must be mentioned.

Subsequently, Dr Charles Zeanah (1997) looked at the attachment process from newborn to 36 months. He stated that zero to

two-month-old babies have a preference for their mothers, but that no clear attachment exists because of the baby's limited ability to discriminate. From two to seven months, Zeanah identifies social responses as the baby socializing with everyone, but that the baby is more comfortable with the primary caregiver. From seven to nine months, Zeanah informs us that the infant falls in love with his mother, begins to have a hierarchy of preferred caregivers, becomes wary of strangers, and protests at separation. The 'secure base period' begins between 12 to 20 months. At this time the infant may venture on his own, using the attachment figures as a secure base, but that proximity to the caregiver promotes internal feelings of security. Zeanah describes how from 20 to 36 months the child gains awareness of conflicting goals. The infant must learn to negotiate autonomous functioning with reliance on attachment figures, and to whom he goes when he needs help. The hallmark of this period is cooperation.

Researchers in the attachment field seem to agree that the primary figures in the child's life are looked upon in their individual and mutual roles as facilitators of the emotional and regulatory organization of the child. These experiences may be acted out within the parent–child relationship. Over several generations, patterns of relating may have been internalized. Furthermore, Mary Main (1985) and her associates have traced the attachment relationship over time, and they have suggested that the relationships between infants and their adult caregivers develop patterns of expectancies, social understandings and strategies that can be seen through non-verbal behaviors that become part of the adult personality. These patterns are organized around strong affective themes and provide direct influences on how young children develop understanding of intimacy, emotions, attachment and their expression of these related issues.

Child psychoanalyst Dr Bertrand Cramer (1990) claims that the studies on interactions over the past 20 years have led to the formation of a diagnostic category named 'relationship disturbances.' He recommends joint parent–infant psychotherapies as one of the best applications for the treatment of relationship-disturbance work. Pioneers in the infant mental health field, such D. W. Winnicott, developed therapeutic consultations with babies and their mothers and from his work we glean the concepts

of the 'good-enough mother,' 'transitional phenomena,' 'the transitional object' (the security blanket, the teddy bear etc.) and the 'transitional space' (1971). Dr Margaret S. Mahler (1975) developed therapeutic consultations with babies and mothers and coined the phrase 'rapprochement stage' which is currently used by many preschool play groups in the community. Selma Fraiberg's (1980) work demonstrated the enormous therapeutic benefits when mothers and babies are treated together, since the mother's own attachment conflicts may tend to be repeated in her interactions with her child, and these may affect the parent–child interactions. Elisabeth Muir (1992) states, 'there is a general acceptance that the intergenerational repetition of relational patterns is transmitted within the interactions between mother and infant. The highly invested nature of the mother–infant relationship makes it a prime area for the playing out of unresolved relational conflicts of the mother' (p.319). She feels that the parent–child interactions may lead to the re-creation of the mother's conflicted past which may be projected onto the child.

Dr Stanley I. Greenspan has been an inspiration to my work. He has researched and intervened with the early childhood population, and he supports the fact that in order to effectively treat emotional and developmental disorders in infants and preschoolers, the therapist must take into account all of the child's experiences. It is necessary, therefore, to have psychological assessments and reports from teachers and parents, to assess the child's developmental level. With this information a model of treatment can be created, in order to look at how the constitutional-maturational, and developmental phase interact with family factors and work together as the child progresses through each level of development.

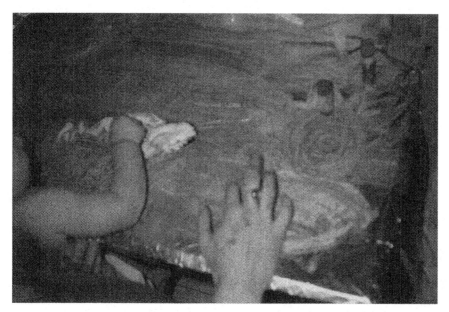

*Figure 1: A ten-month-old girl exploring yogurt finger painting with her mom. The difficulty in tolerating the messy material is resolved by the mother who gives her child a washcloth to manipulate the media.*

## Contemporary parent–child therapy

Several good educational programs available focus on and describe implementing training for parents. Research exists about parents as teachers, filial therapy, and about parent–child interaction therapy to name but a few. During exhaustive research on parenting practices and child development, conclusions have been drawn that parenting reflects interactions between internal representations within parents, genetic predispositions and family and community structures (Minde and Minde 1982). Parent–child psychotherapy is being implemented in several child psychiatry departments the world over. A program for high-risk families and their infant and preschool children is offered at the Douglas Hospital in (Verdun) Montreal. Many interventions such as individual therapy, parent–child interactions, art, play, and occupational therapies form the basis of their program (Dongier *et al.* 1991). The McGill University Health Center offers programs at the Montreal Children's Hospital including parent–child interaction groups for infants aged 18 to 30 months and their primary caregiver. Parent–child-dyad art therapy, play,

movement, and music form the basis of the parent–child communications and interactions (Proulx and Tidmarsh 1997, 1998; Proulx and Minde 1995). A preschool day treatment program is offered for the three to six-year-old preschool population who meet twice weekly, as well as a special four and a half day school based kindergarten program, where parent–child-dyad art therapy becomes an adjunct to the educational and psychodynamic group therapy approach (Canfield *et al.* 1999, 1996; Proulx *et al.* 2001).

'Watching, waiting and wondering' therapy by Elizabeth Muir (1992) of the C. M. Hincks Institute in Toronto applies psychoanalytic principles to a mother–infant intervention. The mother becomes the non-intrusive observer of her infant and only interacts at the infant's initiative. 'Floor time intervention' is play therapy created by Stanley I. Greenspan (1992) where the parent is invited to play at the child's developmental level, following the lead of the child. A variation on these programs is one being developed by J. Harel in Israel. She sees the child and mother together, followed by the father and child together then the mother and child together in play therapy situations. The therapist reflects on the behaviors and actions. Then the parents are seen together for feedback on the child's changing developmental needs, the parents' projections and their perception of the child. (Ben Aeron *et al.* 2001) The Crowell procedure is the 'original study that demonstrated powerful relationships between mother's attachment classifications and mother-toddler behavior during a problem-solving paradigm. Securely attached mothers interacted more favorably with their toddlers and toddlers of securely attached mothers interacted more favorably with their mothers than toddlers of insecurely attached mothers' (Crowell and Feldman 1988, p.1273). Mothers and toddlers with a strong bond interacted more favorably than mothers and toddlers with insecure attachment. This procedure is helps the clinician to evaluate the parent–child relationship difficulties.

In the areas of projective drawings, and of art therapy including mother–child interventions a few studies were found. Jacquelyn Gillespie (1994) describes the use of projective drawing to assess mother–child attachment and relationships. Adults are asked to draw a picture of a mother and child to assist in the understanding of the adult's level of attachment. D. H. Kaiser (1996) discusses the pertinence of drawing in

remodeling the patterns of insecure attachment. She proposes the 'bird's nest drawing' as an art therapy attachment assessment tool. *The Evaluation of the Quality of Parent–Child Relationships: A Longitudinal Case* (Harvey and Kelly 1993) describes observations on affective attunement seen through dance, drama and play therapies practiced with young children and their families. Attunements were defined as clear, shared non-verbal rhythms, postures, gestures and facial expressions, and/or verbal or vocal gestures initiated and matched by their 18-month-old subject and his caregiver. Gonic and Gold (1992), a movement therapist and an art therapist, have written about unstable attachments with children in foster care. Their work is based on the trauma suffered by the child due to abuse or neglect on the part of their parents from whom they must be removed. They focus on trauma and the broken social attachment. Wix (1997) writes about her four year experience with a nine-year-old girl that included a seven month period of mother–child art therapy. Lachman, Cohn, Stuntz, and Jones (1975) focussed on two sessions of art therapy in psychotherapy of a mother and her seven-and-a-half-year-old son. In this case, both the mother and the child were followed in individual therapy. One of the goals of this joint intervention was to focus on their behaviors. Proulx and Minde (1995) report on a group of fathers and their three-year-old offspring. Through father–child-dyad art therapy, play, and discussions, fathers learned about the needs of their toddlers and became more sensitive to them.

Nicole Roy (1999) in a paper about art therapy with high-risk mothers describes her work with pregnant mothers who have identified adult attachment problems. Rubin (1976) in her research concludes that the use of joint mother–child group art sessions at intermittent intervals seems to provide useful diagnostic and therapeutic opportunities for all involved. She mentions a group for mothers and preschool children. She believes for a mother and her child such a shared experience, weekly or periodically, may indeed help them to develop a new mode of communication. Others in the field are focusing on assessments and research: Charles Zeanah and his associates, 'Mothers' representations of their infants are concordant with infant attachment classifications' (1997); Arietta Slade, 'Representation, symbolization and affect regulation in the concomitant treatment of a mother and child:

attachment theory and child psychotherapy' (1997); Alicia Lieberman, 'Clinical applications of attachment theory' (1988); Peter Fonagy and associates, 'Measuring the ghost in the nursery: an empirical study of the relation between parents' mental representations of childhood experiences and their infants; security of attachment' (1993). These are but a few pertinent examples that this author has chosen to exemplify the parent–child work that exists at present in the infant and preschool field; it is not, by any means, exhaustive.

## Parental past conflicts and parent–child-dyad art therapy

Whether at the clinic, the day care, or the shopping center, we often encounter parents who are having a difficult time dealing with their children. Although, when we see them away from one another, both the child and the parent seem to act in a different manner. Comments like 'My child is possessed' may be the primary complaint of the parent to the therapist. 'He is just like my father,' or 'like his father.' These are the everyday expressions containing the projections onto the child. Many childhood difficulties appear to originate with biological characteristics such as temperament and physical or neurological problems. When a child is born with regulatory problems and pervasive developmental disorders, he is less responsive to the interactions of the parent. When a parent suffers depression, postpartum or otherwise, they may be less responsive to the interactions of the child. Certain responses may be triggered in the parent, which they have difficulty understanding, especially when they have had successful relationships with their other children. When a complete family history and childbirth history have been taken, the parents may make a link to an experience that happened to them at a certain age. Often the fears and anxieties resurface when their child reaches the age that the parent was at the time of the traumatic experience. Because of the parent's reactions, the child's behavioral problems become intensified. Therefore, both the child and the parent have equal input into the interaction patterns. C.P. Estes (1996) describes the concept of the 'mental representation,' and of the generational influences on the internal model. She also brings forth the possibilities of reconstructing the attachment and, thereby, changing the internal

representation. Many parents will consult a professional for their child, on their own or at the suggestion of the school, day care, or physician, and at times some parents may seek out their own personal therapies.

In parent–child-dyad art therapy I address the attachment conflicts of the parents in order to reconstruct or strengthen the ties with their child. I begin with the art therapy premise that the adult personality is formed during early childhood, and that spontaneous free art expression assists in allowing the unconscious conflicts and emotions to be expressed (Naumburg 1996). The parent can express deep fears and anxieties without inhibition by sharing and following the infantile art expression. The symbolic language of the dyadic art making often allows the surfacing of emotions that could not be verbalized. The parent, encouraged towards free and spontaneous art expression, may express unresolved conflicts. The spontaneous art expression and playful use of media in dyad art therapy allow both parent and child to project onto the artwork their primitive unresolved conflicts. For the parent these conflicts may have occurred during the non-verbal stage of their life. For the child these conflicts may have occurred or may be occurring during this early stage of their life. Fraiberg (1980) demonstrated the enormous therapeutic benefit of treating mothers and babies together. She refers to the parents' past unresolved conflicts as 'ghosts in the nursery,' and describes how these conflicts interfere with the relationship between the mother and the child, and therefore, must be resolved within the parent–child relationship therapy.

On the same note, child psychotherapist Elizabeth Muir (1992) describes the 'Watching, waiting and wondering' intervention based on the process of projective identification. It is suggested that internal object relations are reflected in the mother's interaction with her infant. In dyad art therapy, the experiences of the child as well as the experience of the parent can be overtly expressed in the art making. Because much of the internal image was formed before verbal language was established, the non-verbal aspect of art therapy allows for the expression of these deep-seated conflicts. It is one of the reasons for building controls into the materials used. The art therapist protects the dyad against 'chaotic discharge' (Kramer 1979) in view of the developmental age of the child, and because the parents' own material is expressed, the 'ghosts' may be

joining us at the art therapy table. Therefore, they must be contained in the artwork and in the rituals of the session.

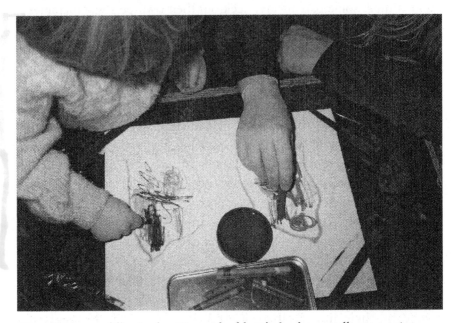

*Figure 2: A mom following her 28-month-old son's developmentally appropriate drawing.*

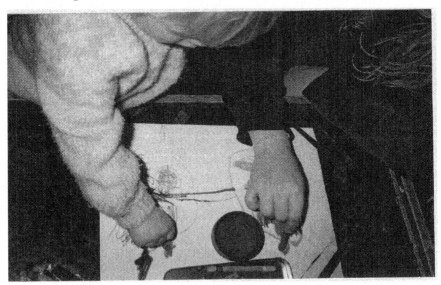

*Figure 3: The boy adds the blue line that attaches the two scribbles together.*

## Theories of child art expression

Since many art therapists, mental health professionals and parents do not know what to expect from a one-year-old child in the way of art making, I am including this short review of the theories of art expression. Much of the literature on child art expression focusses on the human figure drawing that appears around two and a half to three years of age in a child with appropriate development. However, some researchers have looked at child art leading up to the figure drawing, and I will include some of their findings here. Since the children who take part in parent–child-dyad art therapy may be infants, or preschoolers who often suffer from developmental delays, they may not yet have arrived at figurative drawings. Much of the information on working with children begins with school age children. It is, therefore, important to examine the work of kinetic and tactile drawings in order to understand the art of the younger population in treatment.

One of the authors to have studied child art extensively and who has contributed to the field of art therapy is Joseph H. Di Leo (1970, 1973), who asks the question 'What do preschoolers draw?' He compares the child's drawing to that of our prehistoric ancestors who for the first time discovered that they could scratch a mark in the sand or on a wall. The child has also discovered that he can make a mark. Di Leo also believes that the child, in his early attempts at representation, does not try to draw the object as it looks but the idea, the internal model, and produces a schematic reduction to essentials. He confirms his belief by referring to researchers such as Piaget and Read, who agree that a child's image is usually a mental impression imbued with emotions. After many years of research, Di Leo has created a list of answers to his question. He tells us that young children draw what is important to them, predominantly people, then animals, houses, and trees. They also draw some, but not all of what is known about the object, what is remembered at the time, the idea colored by feelings, what is seen. He discusses the voluminous literature dealing with the subject of child art, attesting to the importance placed on it by psychologists, psychiatrists, pediatricians, educators, and artists. Di Leo emphasizes the fact that we all know there is something revealed of the child himself, something intimately personal that will help us to understand the child and his problems. He further emphasizes

the importance of the therapist having a firm knowledge of child developmental sequences. On the other hand, R. Arnhein presents the opposite view. He claims that the child draws what he sees, and that as adults we are also influenced by what we have seen, what we remember at that moment, and by how we feel and think about it. Therefore, what the child sees, his environment, experiences, what he feels (his internal model) are factors that the art therapist takes into consideration with this young population.

When working with the preschool population, the art therapist must be familiar with non-representative art. Since the art we see may be finger painting or scribble drawings it is important to mention the work of Rhonda Kellogg (1970), who for many years traveled the world to study the universality of child art and in particular scribble drawings. In revealing universal qualitative changes occurring in time and sequence and with direction, it may be considered that these studies represent changes occurring in the child due to development or environment. Kellogg has systematically isolated various types of scribbles that a child must have opportunity to practice before being able to draw a human figure. Studying the scribble has also drawn the attention of Grözinger who refers to the scribbles as 'primal skein' and 'primal cross' (1955). He believes that the child is making a statement about himself in his scribbles, and that the adult who attempts to teach him how to draw is bringing the child to conform. He points out that children instinctively draw bi-manually and recommends that youngsters be given the opportunity to draw with both hands, coordinated with breathing. Grözinger emphasizes the importance of motor activity such as rotary movements and places importance upon the actual manipulation of objects. He believes that scribbling is an indication of the child's total development and as such follows a pattern in much the same way as learning to walk. Scribbling is an important part of the youngster's communication with himself and with the outside world. Therefore, scribbling requires an important place in the activities of young children. Grözinger developed a therapy in which the child or the adult creates scribbles using both hands and deep breathing. He explains the importance of scribbling with both hands and its effects on the development of both sides of the brain.

*Figure 4: A joint finger paint scribble with a suggestion of figures.*

*Figure 5: The three-and-a-half-year-old is now able to expresses her sadness about her cat falling into the puddle in an age-appropriate drawing.*

Rather than an age-appropriate development, art therapist Edith Kramer (1979) discusses the development in art making. In the preface of her book she lists precursory activities: scribbling, smearing, exploration of physical properties of the material; chaotic discharge: spilling, splashing, pounding; stereotype: copying, tracing, stereotypic repetition; pictograph: pictorial, communication that replaces or supplements words; formed expression: the production of symbolic configurations that successfully serve both self-expression and communication. These sequences are interchangeable and can be connected to art making, regardless of age. Informal experimentation with the art materials such as mixing paints, watching colors mix and spread, is most helpful. These experiments are not just warm-ups but also important and pleasurable ways of creating new possibilities and taking small safe risks. For the purpose of our work with infants and preschoolers the precursory activities, preventing chaotic discharge, are an important focus. Art educator Victor Lowenfeld (1987) wrote on the therapeutic aspects of art education and described art making in the child as a motivator, based on the factual visually perceivable expressions of the child. The motivations would consist of expanding the child's frame of reference by providing him with meaningful experiences. Art therapist Judith Rubin (1976) describes joint mother–child art sessions for diagnostic purposes. She believes that it is possible to create a situation for purposes of assessment with varying degrees of structure, utilizing all of the art therapy options. Rubin created a guide to assist in assessment that includes observation of the following items: the child's approach to the material, his degree of absorption, energy expended, manipulative action, attitude toward the material, tempo of work, body movements, verbalization, and development or change apparent over time.

The above research has been conducive to the creation of parent–child-dyad art therapy. By combining the contemporary findings with psychotherapy techniques used in the infant and child psychiatry field, and adapting the theories and principles to art therapy findings and practice, I was able to develop this model of therapy.

*Figure 6: Father and his three-year-old son engaged in this finger painting.*

*Figure 6a: Mother and her 24-month-old child created a heavily charged collage.*

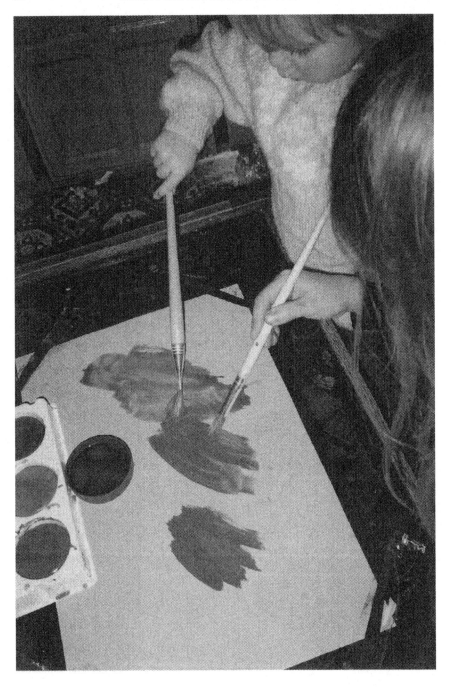

*Figure 6b: Intensely concentrated mother and child.*

# The Role of the Parent
# as Partner in Child Art Therapy

## A clinical experience

My first clinical experiences as an art therapy intern in the infant and preschool field involved working with a 30-month-old and his mother, then with and a three-year-old and father utilizing individual dyad art therapy. These experiences convinced me of the benefits of working therapeutically with the dyad, and circumstances provided me with opportunities to put my beliefs into practice. I later discovered that my thinking was similar to that of many researchers in the field of infant mental health. One such researcher, Susan C. McDonough (1995), who developed an approach called 'interaction guidance,' explains that despite varying professional backgrounds and theoretical orientations, workers in the field of infant mental health seem to be united around the common assumption that 'infant behavior cannot be viewed separately from the young child's relationships. The transactional model of the baby affecting and being affected by the caregiver results in developing approaches that focus therapeutic treatment on infant-caregiver relationship rather than on either the infant or the caregiver alone' (p.485). McDonough further states that infant-caregiver interactions are understood both as an indication of family structure and care giving nurturance, and as a reflection of the caregiver's and infant's representational worlds.

It has been proven in the field that assessments and interventions with infants, toddlers, and preschoolers, are aimed at prevention. Therefore, the infant is not separated from the parent, since this would cause the

child undo anxiety. Identification of risk factors and intervention before the appearance of disorders are central to effective results (Emde and Sameroff 1989). It is also widely believed that these interventions are key to the prevention of mental disorders throughout the lifespan (Fonagy 1993). Dr Bruce Perry (1997) states that 'recent research suggests that identification and resolution of psychiatric disorder during the first three years of life prevents internalization of disordered neural patterns in rapidly developing and organizing brain structures' (p.31). Researchers agree that because infants and toddlers are maximally dependent on parents, most of the facilitation of change must be accomplished through the parents, making their role in treatment of primary importance.

As an art therapist, I felt that it was most important to create an art therapy intervention with this population, based on existing attachment and relationship theories. It was also important that the parent be included, that the art activity, though developed to suit the infant's age of development, be attractive to the parent participating with his/her child.

## Format and process

The parent–child-dyad art therapy groups comprise a maximum of six dyads with an art therapist and a co-leader. The co-leader can be the classroom teacher (in schools), the group therapist (adjunct therapy), or an art therapy intern (parent–child interaction group). This makes 12 persons for the group therapist to interact with and contain. Fathers and mothers are invited to attend this weekly session one parent at a time. It is important not to create a situation where the child is caught between the dynamics of the parents. The child must not be in between his parents as he will be unable to satisfy the demands of both of them. The aim of the intervention is to work on the relationship with one caregiver at a time. The child cannot participate in this art therapy intervention without having a primary adult to contain him and help him follow through with the process. There are times, however, when the parent cannot attend; exceptionally, a nanny or a grandmother will accompany the child, or the child will be paired with the classroom teacher, the group psycho educator, or the intern. With preschool children, it is best that the child

not miss the group play therapy or the kindergarten class that follows the art therapy intervention.

The sessions are designed to help the parent follow their child's art making at the child's developmental level. The parents are invited to sit at child-height tables and chairs, enabling them to sit at the child's level and make eye contact, rather than having the child look up to the level of the adult. This perspective gets the parent to do things with the child at the level that the child can do them. This validates the child in what he is able to do, rather than trying to make him attempt something he is unable to do. The materials and activities should be presented in such a way as to make it difficult for the parent to do much more than the child. The sessions have to be constructed so that the parents will want to do the primitive artwork. The material and activity must be interesting and inviting and must assist in getting the parent to regress to the developmental age of their child. The containing aspects of the activity and of the materials can allow the unconscious regression in the artwork of the parent.

*Figure 7: The materials and activity must be interesting and inviting to help the parent work at the developmental level of their child. The parent must be seated at the child's eye level in order to follow the child's lead. Protective aprons help the parents tolerate the messy material.*

Pioneer art therapist, Edith Kramer (1979) emphasizes that every stage in the development of art reflects emotional growth. She states that 'art and the creative process involves a complex comprehension both of the physical handling of art materials in order to form them so that they serve as symbolic equivalents for human experience, and the psychic processes that motivate creative work. Some understanding of these ideas about the nature of art is necessary in order to understand the function of art as therapy' (p.xxviii). The art therapist, by creating age-appropriate art experiences and giving verbal and non-verbal directives in the use of materials provided, encourages the parents to follow the child and not to teach or intrude in the child's art expression. By following the child, the parents are enabled to return to a period in their own early childhood and experience deep emotions. This way of using art material is described in the literature as 'precursory' activities: scribbling, smearing, and the exploration of the physical properties of the material that are 'ego syntonic' (materials and activities that are compatible with the infant's abilities that may reinforce the ego). The art configurations may be symbolic of the early attachment period. The primitive production of art becomes symbolic of the secure base interaction and creates the exchanges required to develop positive parent–child interaction. The parents often comment: 'I haven't done this since kindergarten,' or 'I have never tried this,' 'This reminds me of my mother' etc.

When the parent chooses a teaching mode of interaction with their child they are functioning in the intellectual mode because they are usually very defensive about engaging in infantile art making. This model allows the art therapist to assess the dyadic interaction as well as the emotional and developmental levels of the child and the parent. The therapist then provides the material and the therapeutically structured activities to facilitate growth in the parent–child relationship. Since the media and the art making are utilized symbolically to recreate the early parent–child interaction, non-traditional materials such as cornstarch (with its strong resemblance to baby powder) usually trigger memories in the parents of their first encounters with their baby. It is a happy period for most of them. The flour and food coloring, which represent feeding, are familiar and non-threatening, and help the parent return to that early period of the child's life. This can often lead to discussions of feelings

concerning their child's feeding problems. For many parents, kneading dough is a new experience; for others, it reminds them of their childhood, or of the food they make regularly. These everyday materials included in the therapeutic activity, along with the use of traditional art media, must take into consideration the developmental level of the child.

Art therapist, Cathy A. Malchiodi (1998) agrees that it is equally important for the therapist to have a working knowledge of art materials. She acknowledges that if a therapist is not familiar with art materials and what they can do, she may have difficulties working with children. 'It is equally important for the therapist to have a working knowledge of drawing materials. If a therapist is not familiar with art materials and what they can do, the child cannot be adequately instructed in how to use the materials to make well-formed and expressive drawings. Personal experience with the art process cannot be overemphasized, and direct involvement with art materials is highly recommended as a way to truly understand materials because verbal observation will not adequately convey this information' (p.28). This knowledge of art materials is of great importance when working with the dyad. The media are presented in a manner that will support ongoing positive communication between the dyad and the art therapist. Limits are built-in to prevent control issues from surfacing as chaotic discharge, thus ensuring a meaningful, therapeutic experience for both participants. The ritualistic repetitiveness of the opening and closure of the art therapy intervention creates an experience of trust and predictability, which is invaluable to secure attachment.

Images are made with the dyad sharing one piece of paper. This paper is firmly attached to the table with tape forming a secure base. When the session is complete, the parent and the child remove the paper from the table together, carry it together, and attach it to the wall. This is not an unusual practice in group therapy sessions, but with the dyad intervention, the art production remains on the wall, in the clinical setting, during the play group therapy with the preschool group. The artwork becomes a reminder of their parent's presence and allays anxiety. With the infant group, the child takes the work home to display it there. This is a change from the usual protocol in art therapy wherein the art production is kept safely by the art therapist. However, the 18 to 30-month-old child

*Figure 8: Sharing one piece of paper helps this four and a half-year-old child express her feelings about the baby in her mommy's tummy. It is easier when mom helps make this a colorful drawing.*

benefits from carrying home the joint project, and displaying it at home serves as a reminder of the closeness of the interaction. It becomes the transitional object that includes elements of both the parent and the child. The parents often report the pride the infant has in showing his work to family members. The art therapy intervention is designed to provide the dyad with proximal (close) and distal (distance) experiences. The activities are designed to ensure close and separate experiences throughout the intervention. In one session, the activity might take place on 12" x 30" paper that the two work on together, while in the next session the table may be covered with a larger paper that the whole group will paint on together. In this way, the dyad experiences intimate closeness as well as sharing with the community. During other activities the child will leave the table to get more materials for the activity (this provides the separate experience), or work with separate pieces of clay,

etc. The art therapist must plan her interventions to take into account closeness and separateness. Through that process, the art making provides an experience conducive to secure attachment.

*Figure 9: Table painting is fun at any age. At this time parents have the opportunity to share some of their early memories and experiences.*

In the preschool children's groups after the dyad art therapy intervention, the parents leave the room to go to their own individual psychotherapy or counseling sessions within the clinic. This separation is also an important part of the attachment process, and must be taken into consideration. Though the parents leave, the dyad artwork is left on the wall. During the separation activity the preschool children – who might start forgetting where 'mommy' is – will at times go up to their artwork and say 'I did that with Mommy' or 'I did that with Daddy.' This contact with the art reinforces the child's mental representation of the parent. A non-traditional art making material such as flour is introduced several times in a group effort to make play-dough. We discovered that after the parents leave, the children who wanted to play in the kitchen corner with the play-dough they have made with their parents would sometimes go to the shelf and get the little 'parent puppet.' They would put that puppet

on the table while they used the play-dough, recreating their recent closeness with their parent.

## Integration and application

In this section, I will describe a few of the therapeutic play groups in which the parent–child-dyad art therapy intervention was integrated. I will begin with the parent–infant group (zero to three years) and continue with adjunct dyad art therapy with preschoolers (three to six years). The dyad art therapy application is broad and effective as the following specific examples show.

### A group for father and child

Professionals at the Montreal Children's Hospital Family Infant Team were well aware of the works of Pruett (1985), underlining the importance of the father's role in the infant's care, and the fact that few programs for fathers were available. Our research found only a few programs dealing with fatherhood issues. One was being conducted by Jacquelyn and Michael Resnick (1980), and published in the journal *Counseling Man*. The chapter addressing 'Fathering Classes' described a psycho/educational model that addressed fathers and prepared them to play a more active role with their child. Paulina Kernberg of the New York Hospital Center created a video *Fathers on Fathering* (1991) which focussed on the experiences shared by fathers at a monthly open house for them and their offspring. The information from this video caused us to focus on the needs of fathers. Therefore, the multi-disciplinary team was encouraged to offer a therapeutic group to fathers in order to inform them about child development and permit them to focus on themselves, their role as a father, and the needs of their child. The group consisted of three dyads: three fathers and two boys, 36 months, (demonstrating aggressive behaviors toward their parents), and one hyperactive girl, 30 months old. The group had clearly defined goals:

1.  To transmit information about the emotional, social, and cognitive development of the child, and the age-appropriate capabilities of the child.

2.    To reinforce the emotional ties between father and child; to provide a framework that would contribute to the growth of each child.

3.    In addition, to create an atmosphere favorable to sharing the common preoccupations of fathering.

The project also aimed at creating a forum where the fathers could experience positive interactions with their child, observe other fathers' interactions, and feel safe enough to express their feelings in a supportive environment. The group was led by a child psychiatrist (the symbolic father) and myself (the symbolic mother). The format began with a group dyad art therapy intervention that provided each parent and child with a close intimate experience, followed by a free play experience that permitted closeness and separation, and finally, a time for fathers to sit with the child psychiatrist and discuss fathering issues. This created a separation situation. It was hoped that through the making of art at the infant's level, the fathers would reconnect with their own creative vitality. The free play portion permitted observation of the relationship and allowed for hands-on interventions by the therapists. These activities were followed by the group discussion with the fathers and the psychiatrist, while the children played in full view of their fathers, providing a distal experience. Clean up completed, the group participated in a singing and rocking activity in a hammock-like sheet held all around by all the participants. This was followed with snacks and good-byes. It became immediately obvious in the dyad art therapy that the fathers were not attuned to the development levels of their children, expecting them to perform above their abilities, wanting them to copy what they were drawing. With some guidance and intervention, it was exciting to see the positive changes in the interactions that occurred during the eight sessions. A before and after questionnaire was given to the fathers that assisted in measuring any progress (Proulx and Minde 1995).

*Parent–child interaction group*

The success of the fathers' group convinced the Family Infant Team to continue with the group format for cases that might benefit from group interaction and art therapy. We conducted more research to discover if

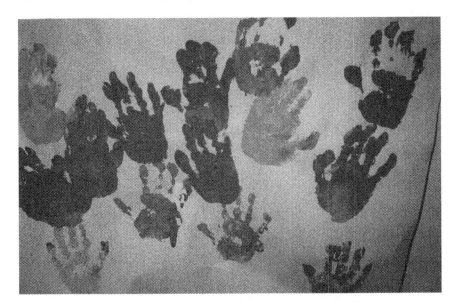

*Figure 10: Big and little hands. Everyone gets his or her hands dirty.*

models of our intervention already existed. The Anna Freud Center in London advised us that they work with parents in a mainly child-focussed way; they refer to their work with mothers and their infants (one to three years) as 'parent guidance.' Our work would therefore differ from this approach. Other inquiries were based on individual dyad play therapy, or mothers' groups without the children.

The group intervention developed in the Family Infant Team was co-led by a psycho educator, child development specialist and an art therapist. One of our criterion for admittance was the mother's ability to look at her own interactions, her motivation to participate with her child, and her willingness to observe the interactions of the other dyads. Our aims were to strengthen attachment ties between the parent and the child, encourage group interaction, make the parent aware of age-appropriate child development, and to raise their self-esteem as 'good-enough' parents. Parent–child-dyad art therapy formed the basis of a parent–child group for 18 to 36-month-old infants. In this format, the parents stay with the child for the entire one hour and 15 minute session. The art therapy intervention seemed more effective at the beginning of the session, but as space or accommodation are often not ideal, I have, at

times, placed the art therapy intervention at the end of the group. It is important for the art therapist to consider these factors when designing therapeutic art activities.

This group is offered in blocks of ten weeks, each session lasts one hour and 15 minutes. A maximum of six dyads attend. Mothers or fathers with infants aged 18 to 30 months are offered the intervention. The parents have the option of alternating, but only one parent attends the group at a time. The art therapy intervention takes up the first half hour of the group, followed by free play, at which time the parents can share concerns and successes. Singing, book reading and a 'rock-a-bye baby' activity ends the session. The group experience concludes with a snack and positive feedback. The children take their artwork home with them. The symbolic content of the material is meant to recreate a very early communication experience, that of the parent following the child's developmental level of interacting. These early interactions, such as the mirroring and the reciprocal 'cooing,' promote the falling in love stage that is the basis of internal representations.

In many cases, because of parental depression or other problems, or because of the child's regulatory problem (e.g. a child who cannot sleep, cannot eat, has colic or who is hard to contain) something happens that we might call a disturbance in the relationship. The parent–child relationship may have gone askew from the time of that love period, or perhaps that love period never occurred, so that we have to symbolically re-create it. Art therapy allows us to do this through the symbolism of the media and the art expression. The team assesses the dyads participating in this treatment, and the Crowell relationship procedure (see Appendix A) is applied, then the psychiatrist who heads the team formulates a diagnosis. The parents attending the interaction group are followed regularly by a case manager who may have to deal with marital conflicts or personality disorders. The interaction group therapist (who may also be the art therapist) reports to the team on a weekly basis (Proulx and Tidmarsh 1998). Details and examples on the workings of the parent–child interaction group are given in Chapter 4.

## Dyad art therapy as an adjunct intervention

The parent–child-dyad art therapy intervention can be applied to many groups that have already been established. However, with the help of an experienced group therapist as the co-leader, the application of the dyad intervention becomes a workable model. The art therapist must take into consideration that the parents will be leaving the group at the end of the half hour; that the art therapist will also leave the group. Therefore, closure of the art therapy intervention must be carefully planned in order to facilitate the child's painless, successful separation from the parent and vice versa and their reintegration into the group therapy.

### In a preschool day treatment program

The Preschool Day Treatment Center at the Montreal Children's Hospital offers therapy two half days weekly for preschoolers with developmental, behavioral and emotional problems, which are often expressed as anxiety, depression, and somatic complaints, aggressive behavior or in learning problems. Throughout the therapy sessions, the children are able to talk freely about an experience or about themselves. In a fully equipped playroom, structured play activities such as problem-solving tasks, storytelling or painting and drawing are presented followed by free play. A snack is provided during the final 15 minutes of the session. The group therapist utilizes behavioral, developmental, and psychodynamic theory in planning and carrying out the program. Interventions are designed to facilitate verbal expression, peer socialization, and development of play. The therapy rooms are equipped with a viewing screen so that parents may regularly observe and discuss their child's behavior and the therapist's interventions with the case manager who provides individual parent counseling. Emphasis on work with parents is to enhance their understanding of the developmental needs of their child and their parenting skills. Promotion of positive interaction between parent and child is a central focus.

The decision to invite the parents as partners into the preschool child's playgroup psychotherapy began as a pilot project. My colleague, a psycho educator and therapist working with the three to six-year-old group, wanted to develop a closer therapeutic relationship with the parents of the children coming to treatment. We hoped to eliminate

conflicts that could occur for the parent, having to leave the child in the waiting room to go with the group therapist. By adding dyad art therapy to the beginning of one of the two play group therapy sessions, the parents, as partners in treatment, did not feel envious, rejected, or insecure about their child. By including the parent in the group, the parent did not feel that she was abandoning her child to the group, to strangers. The art therapist's aim was to provide a safe transitional space for the parent to communicate with the child through art making. We also hoped to eliminate emotional stress through art, and to create a secure base where a positive mental representation could develop. The dyad group also synthesized the interventions of the case managers, the child's group therapist, and the art therapist.

The group therapist immediately observed a change in the children. The intensive interaction with the parents sometimes caused the pre-schoolers to be more agitated, or calmer, after their parents left the group. At times, this reaction was reflected in the whole group. The parents also began to form close alliances with each other and with the therapists involved in their treatment. The use of the parent–child-group dyad art therapy intervention proved that the creative process could be a method both of reconciling emotional conflicts, fostering self-awareness and developing personal growth in the dyad (Proulx, Aspler, Canfield 2001).

*In a kindergarten classroom*

The school based kindergarten project is a response to the need for early detection and intervention for kindergarten-aged children with developmental delays, accompanied by behavioral impairment. Young children with behavior and developmental disorders can now be identified at an early age. As these children are at a greater risk for development and conduct disorders and/or learning disabilities, it is proposed that early diagnosis and intervention could lead to a significant improvement in their socially maladaptive behaviors and an amelioration of their developmental difficulties. The goals are to provide a positive school experience through the promotion and development of appropriate behavioral, social and academic skills; to develop a cooperative working relationship with the parents; to foster attachment and cooperation, in order to facilitate growth, self-esteem, and

*Figure 11: Parents' fantasies are expressed in this multi-media collage, with mother and child handprints.*

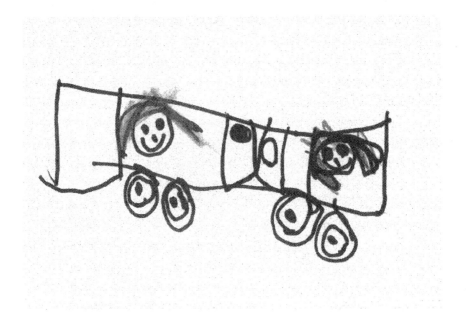

*11a: A joint pretend trip. Going on a vacation together.*

enjoyment. Therefore, the parents participate once a week with their child in an art therapy intervention, in the classroom. When the dyad art therapy session is over, parents leave the children, who are supervized by a child-care specialist, to discuss the group experience and their overall problems and concerns. The experience of producing spontaneous art using a shared format is the basis of the intervention. Gradual and respectful movement away from one another occurs as autonomy develops. As the group became cohesive, the parent discussions in the second half of the intervention gathered such importance that the parents expanded them to one hour with the support of the teacher and the art therapist. The parents began to wait to collect their children at the end of the class.

Self-esteem and self-awareness issues surfaced readily in parents during discussion about art experience with their child, their child's developmental progress, and their family's ongoing contacts with the clinical staff. These experiences were exchanged and elaborated in an attempt to grasp the experience as meaningful. Thus, the relationships among parents, children, school personnel, and clinical staff were established and enriched. Parents who are helped through the stages of the intervention by participating in the process have come to an improved understanding of their child's problems. These parents often improve their ability to follow-through with their children and became more cooperative with the teacher in order to help the child toward resolving classroom difficulties (Canfield *et al.* 1996–1999).

## In a group for divorced mothers with children

Since so many of the families applying for outpatient treatment in child psychiatry were single-parent their commonalities led the social worker to start a mutual aid group for divorced mothers of child psychiatry patients. The group therapy workshop was held in two rooms. The divorced mothers' group was led by the social worker, and the children's group, ranging widely in age, was held in a larger room and animated by volunteers. I was asked to introduce the art therapy experience during four meetings of this group, twice with the parent group and twice with the mothers and the children together. In this manner the parent–child interactions could be addressed directly and the therapist was able to get

*Figure 12: Painting a happy ending fairy tale with mommy.*

non-verbal and visual information that had not previously been available to her. The art therapy intervention, which involves inter/intra personal relationships as well as a learning process within the structure of the activity, addressed the needs of emotionally disturbed children and their mothers experiencing social adjustment problems. All the participants found the experience beneficial and asked that more art therapy sessions be made available (Bezonsky, Gutman, Proulx 1989).

*Figure 13: Parental and childhood anxieties may be expressed together.*

## In individual dyad therapy

In individual work, it is often beneficial to address the problems through parent–child-dyad work. It has been identified that children with feeding, eating, or dressing problems need tactile stimulation because many of them suffer from a tactile over sensitivity. Other referrals come for children suffering through separation or divorce, cases of sexual abuse, or trauma due to accidents or hospitalizations. Therapy is aided when the parent is able to work alongside the child. The child feels more secure with the parent participating, especially in cases of extended separation from a parent, adoption or attachment issues. Therefore, in my clinical work in private practice, after a thorough evaluation of the family, parent–child interventions may be recommended. Parent–child-dyad work has been successful with children of all ages. Dyad art therapy has been successful with children as young as ten months, and adolescents. It is important at the same time that the parent, who has issues to resolve, be seen by his or her own therapist (see Chapter 4).

*Figure 14: Unresolved conflicts may take form in the artwork.*

In conclusion, I have attempted to outline how this parent–child art therapy approach includes parents as partners in the therapy. This approach helps parents recognize their children as individuals and begin to take their child's concerns seriously. This therapy guides parents to begin to respond in ways that are supportive and productive. The spontaneous artwork produced in this dyad therapy, no matter at which infantile stage, represents the unconscious processes of the participant. This is what the therapist wishes to ellicit in the images of the art production. These pictures represent a direct form of communication that functions as symbolic speech and may effectively release many repressed feelings more directly and more swiftly than words.

# The Sensory Experience and Internalization

The parent–child-dyad art therapy intervention was originally introduced to encourage interaction between the child and the parent. Through the help of metaphor and the re-creation of rituals and symbols of a very early communication mode, the dyad's bond may be strengthened. Sensory and tactile activities have been designed to assist the parent with interactions at the developmental level of the child, and in this manner accompany the child in integrating skills already acquired. The parents begin to express their enjoyment of and amazement at their child's age-appropriate capacities, and at the same time, they may be recapturing early moments of their own development. I began to suspect this through the anecdotal material from the parents. While following their child's lead and using infantile art, some of the parents seemed to be gaining insight and appeared to be resolving their own issues. This seemed apparent through the level of enjoyment expressed by the parent, and in the changes that were occurring in the dyad interactions. Research in the field of child development has now produced interesting information on how sensory stimulation and parent–child interactions wire neural circuits and strengthen synapses in the brain. That research brings a logical understanding to the process and results of parent–child-dyad art therapy.

## Sensory stimulation and the brain

> The Baby was born with a head on her shoulders and a mind primed
> for learning. However, it takes years of experience – looking,
> listening, playing, and interacting with parents – to wire the billions
> of complex neural circuits that govern language, math, music, logic,
> and emotions. (Begley 1997)

In a *Newsweek* article entitled 'How to Build a Baby's Brain' (p.30–31),
journalist Sharon Begley describes how pediatric neurobiologists can
measure activity in a baby's primitive brain stem and sensory cortex –
from the moment a baby is born – by using a positron-emission
tomography (PET) scan. They can observe the formation of synapses, the
microscopic connections responsible for feeling, learning, and
remembering. PET scans of a normal child's brain show regions of high
and low activity. Primitive structures such as the brain stem are fully
functional at birth. Regions of the temporal lobes, however, are 'wired' by
early childhood experiences. Research conducted on the brain of a
Romanian orphan institutionalized shortly after birth shows the effects
of extreme deprivation in infancy. The temporal lobes that regulate
emotions and receive input from the senses were nearly quiescent. Such
under-stimulated children suffer emotional and cognitive problems.
Early childhood experiences exert a dramatic and precise impact on the
wiring of the brain's intricate neural circuits, and researchers are learning
how these experiences affect neural circuitry. A baby's experiences
strengthen his brain's synapses. Unused synapses will wither away in a
process called 'pruning,' but stimulation reinforces these wispy
connections.

In her article, Begley states that according to Dr J. Chugani, a
pediatric neurobiologist, the formation of synapses and their pruning
(synaptogenesis) occur at different times in different parts of the brain.
The sequences seem to coincide with the emergence of various skills. One
example, which relates to the theme of parent–child-dyad art therapy, is
causality. According to Begley (1997) causality, a key component of
logic, is also best learned through emotions: 'If I smile, Mommy smiles
back.' A sense that one thing causes another forms synapses that will
eventually support more abstruse concepts of causality. Feeling, concepts,
and language begin to be linked in this way (p.31). Dr Bruce Perry of the
Baylor College of Medicine believes that experience may alter the

behavior of an adult, but that it is the organizing framework for the brain of a child. The brain's organization reflects its experience. Repeated traumatic or overwhelming experiences change the structure of the brain. According to Dr Linda Mayes of the Yale Child Study Center, trauma elevates stress hormones, such as cortisol, that wash over the tender brain like acid. As a result, regions of the cortex and in the limbic system (responsible for emotions, including attachment) are 20 to 30 per cent smaller in abused children than in normal children. These regions also have fewer synapses (p.32).

In adults who were abused as children, the memory-making hippocampus is smaller than in those non-abused. This is believed to be the result of the toxic effect of cortisol, brought on by trauma and stress. Perry (1997) explains that regions activated by the original trauma are immediately reactivated whenever the child dreams of, thinks about, or is reminded of the trauma. The slightest stress or fear unleashes a new surge of stress hormones causing hyperactivity, anxiety, and impulsive behavior. Neuroscientist Megan Gunnar of the University of Minnesota reveals that 'kids from high-stress environments have higher cortisol levels, score lowest on inhibitory control, and have problems in attention regulation and self-control' (p.32). This new information about brain development has very profound implications for parents and therapists. It emphasizes the importance of hands-on care giving, and dyadic interactions such as cuddling babies, talking with toddlers, or providing infants with stimulating experiences. Further research regarding internalization and sensory integration is being conducted in the fields of psychology and occupational therapy. Psychologist Arietta Slade (1996) examines representational and metacognitive processes in attachment theory research, and adult attachment representation.

It is agreed by many researchers in the field, including Main et al. (1985), Fonagy et al. (1993), and Crowell and Feldman (1988), to name only a few, that the quality of a mother's attachment organization predicts her infant's attachment. Mothers who were guarded against the memory and power of their own early childhood experiences or who remained overwhelmed by such memories and feelings had children who disguised their needs for comfort and became so overwhelmed by distress that they were unable to successfully separate or explore their environment

independently. Thus, research in the representational area underscores the powerful relationship between the mother's representation of her own early attachment experience, that is, her internal image, and the quality of her child's attachment. It would appear that the internal representation of the parents affects the internal representations developing within the child.

## Internal representation and art therapy

What is the role of art therapy in sensory and tactile stimulation and internalization? What information could art therapy uncover using new research methods now available? Can changes within the parent be measured, and if so, how? This whole concept opens up new possibilities of research for art therapy. At the University of California's San Francisco Injury Center, Linda Chapman (2001) and associates are developing research methods and art therapy techniques with trauma victims. The Chapman Art Therapy Treatment Intervention (CATI) is a therapeutic method that begins with graphic kinesthetic activity such as scribble drawing, which is designed to stimulate the formation of images by activating the cerebellum. The motor activity is said to allow for a release of tension and the rhythm and motion serve to induce relaxation. The kinesthetic drawing intervention activates the limbic system, which is the center for emotional and perceptual processes. Behaviorally, emotions are often expressed in tears or loud, angry voices. This research brings us closer to the concept of art therapy and internalization.

Much research has gone on in art education regarding the development and the function of child art. W. Grözinger, art educator, researched kinesthetic drawing; in his book *Scribbling, Drawing and Painting* (1955), he cites the work of Max Verworm (1907), who describes a model of the brain. Without the aid of PET scans or similar technology, Verworm attempted to understand the possible connections between the stimulation of the retina and the optic nerve tracts to the brain, and the ganglion cells in the optic nerve. He explains how sensory perception and observation occur by mapping the appropriate muscles of arm and hand to corresponding motor centers that form memory areas of association. Verworm states that this is predominantly the way children

draw. Grözinger hypothesized a connection between scribbling with both hands and effects on the brain; using Verworm's model he devised a therapy for adults and children which encouraged the use of both hands and deep breathing while scribbling, as a way of centering and balancing the individual. He named the resulting art productions 'breath patterns.' It is not the focus of this book to list the multitude of research on child art, but the research, in view of the findings on stimulation and brain activity, confirms that most children follow a predictable pattern in mark making.

## Emotional development and art therapy

The infant's emotional experiences structure their brain development, an evolution that occurs in stages. Brain activity, physical and intellectual development, and emotional maturation are now the focus of extensive research in this field. Pioneer researchers such as Bowlby, Ainsworth, Winnicott, Mahler, Waters, Zeanah, and Greenspan are but a few of the plethora of researchers the world over who have documented and reported on the emotional development of the infant. In the field of art therapy, investigators have been documenting the stages of art, and the importance of early mark making to the child's development of a sense of self as well as doing research on mental representations. The importance of kinesthetic drawings and sensory activity at all ages is noted in many art and art therapy documents. Confirmation of this importance can be found in the writings of Di Leo (1972, 1973), Malchiodi (1998), Kramer (1979), Levick (1983), Rubin (1984), and many others. In dyad art therapy the group becomes the transitional space. Because both the parent and the child make marks on the same paper, the joint artwork may become a transitional creation, holding aspects of both the child and the parent. It can, in this way, become a 'me-not-me' (Winnicott 1951) object.

It is important at this time for me to elaborate the work of child psychiatrists D. W. Winnicott and Stanley I. Greenspan. Both pioneers in the field of infant work, their theoretical statements have contributed to the development of parent–child-dyad art therapy, and I frequently refer to their work and quote them throughout the book and especially in order to articulate this chapter. Winnicott (1971) elaborated the concept

of the 'transitional phenomena.' He begins by commenting on observations of the infant who uses fists, fingers or thumbs to suck on. He comments on how parents tend to give their child a soft toy or doll to hold, suck on or play with, and he emphasizes these interactions as important to be studied. He categorizes such things as:

1.    the nature of the object

2.    the infant's capacity to recognize the object as 'not me'

3.    The place of the object – outside, inside, at the border

4.    the infant's capacity to create, think up, devise, originate, produce an object

5.    the initiation of an affectionate type of object-relationship.

Winnicott describes the object, toy etc. as a transitional object that helps the child to deal with not having his mother with him at all times. He states: 'one may suppose that thinking, or fantasying, gets linked up with these functional experiences' (p.4). He goes on to describe 'the 'good-enough mother' (not necessarily the infant's own mother) as one who makes active adaptations to the infant's needs, an active adaptation that gradually lessens, according to the infant's growing ability to account for failure of adaptation and to tolerate the results of frustration (p.10). Winnicott reminds us that the mother, although she starts off with an almost complete adaptation, will adapt less and less according to the infant's ability to deal with her failures. Therefore, he brings us to the understanding that the mother is not perfect, but 'good enough.'

The theories and concepts of Winnicott are used in the parent–child-dyad intervention. You will note that I refer to the work produced by both the child and the parent as a transitional object and the process of the therapy as occurring in a transitional space. In addition, I underline the importance of the therapist when working with the dyad to focus on the relationship, in order to allow the mother to be a 'good enough' parent so that the therapist does not become the 'good mother.' It is recommended that art therapists and mental health professionals acquire knowledge of Winnicott if they are to work with the infant population.

Stanley I. Greenspan's functional and emotional developments of the child are broken down into four practicable categories that help the art therapist observe dyadic interactions. The implications of multi-sensorial experiences and affective contributions to early ego development are clearly defined with the infant observation criteria. Greenspan outlines experience and sensory motor patterns as ways in which the infant organizes experience along the interrelated dimensions of sensory and thematic affective experience stage by stage. Therefore, the baby's ability to do things helps him to organize his experience, and to regulate his emotions. The sensory pathways are described as being observed in the context of sensory-motor patterns. In order to clearly describe emotional development, related to the physical development of the child, this author has chosen to focus intensely on the work of Stanley I. Greenspan, since it has been my experience as an art therapist that the emotional development stages described in his book give the practitioner some insight into ego development, how it is connected to the sensory experiences of the infant, and how it leads to internalization.

At the zero to three months stage, the baby is described as being interested in a variety of bright, attractive stimuli. This external stimulus provokes motor output: the child turns towards it, reaches for it, kicks at it, makes noises at it, coos, laughs, cries, etc. 'The baby who wants to be interested in the world can, with a certain posture or glance, often let his primary caregiver know he is ready for interesting visual, auditory, and tactile sensations' (p.746). In other words, the infant learns to look, listen, and attend in order to experience attachment to the parent. This stage, Greenspan refers to as 'attention and engagement.' It is important to look for this core process of attending and engaging in two and three-year-old children and in the interactions of their parents. Difficulties with proper negotiation of the stage of attention and engagement may underlie problems the dyad experiences with sleep, feeding, or behavioral problems such as hitting or biting.

However, in clinical work, I have encountered children who appear not to have negotiated this early stage of communication, that is, they are not easily stimulated, and many times I have also noted parents who did not seem capable of these early interactions. The parent may well be exhausted by the effort it takes to involve the child. The art therapist,

therefore, must be prepared with a variety of ways to stimulate the child and interest him and his parent in participating. It always surprises me, when working with the infant population, how readily they come to trust me and the art making process. Moreover, as early as the second session, they come to the table, sit quietly next to their parent, and look interested and ready to participate, even if they had been insecure and fidgety at the first session. This often amazes the parent who has consistent difficulty with their child's behavior. Even the youngest child seems to say, 'I can do this, I am ready, and you understand me.' The parent is then also ready to interact, as they feel understood, and not judged to be bad. The stage of engagement is observed when the child pays some attention, without comprehension of the media. He is slowly introduced to the activity by observing his parent, who follows the therapist's lead. Because this experience is new to the dyad, both parent and child learn together. Often, the parent must be reminded to slow down in their exploration, and follow their child's lead in order to remain at the child's developmental level. Together they attend and engage.

During the next few months, babies enter a state of cause-and-effect interactions going beyond states of shared attention and engagement. This development is referred to as 'two-way communication.' At this point, in addition to a motor and sensory dialogue between the caregiver and the baby, there should be an emotional, social, and intellectual dialogue. Greenspan (1992) describes this process as opening and closing circles of communication (p.7). A simple example of this process is the baby who coos (opening a circle) and the parent who responds with the same coos (closing the circle). In older children, a difficulty in two-way communication processes may show up as an aggression problem. Most children learn to comprehend limits from gestures, not from words. The child may not properly negotiate the pre-representational stage of non-verbal gestural communication if the parent has not already properly negotiated it. Therefore, the art therapist must be prepared to model this stage to the parent, who will mirror it to the child. For example: the child and the mother sit in front of a simple collage activity. The mother worries that she will not do this right, so does nothing. The infant sits, becoming fidgety and impatient. The mother becomes exasperated. The therapist picks up a piece of interesting paper,

plays 'peek-a-boo' with the child, and places the paper on the pre-glued surface. The child smiles, the mother smiles and now knows what to do. Gestural communication and the cause and effect stage are in the process of being negotiated.

If, within the dyadic interactions, there is no special emotional interest in the primary caregiver, it may be due to a problem in the attachment stage of sensory organization. Infants who appear to have gained organizational capacity may be ready to explore. The secure child may also allow his mother to leave the room on occasion and still feel confident that she will return. Greenspan (1992) agrees with contemporaries in the field: that in babies between two and seven months old, there is a relative lack of differentiation of self and object, which characterizes ego organization, differentiation, and integration. A baby's smiles and body movements in response to his mother's gentle voice and touch is the most vivid example of attachment. 'The task of attachment, organizes a number of discrete affective proclivities, including comfort, dependency, pleasure, and joy, as well as assertiveness and curiosity, all in the context of an intense, affective caregiver-infant relationship' (p.748). The child who experiences an environment that is not conducive to secure attachment may experience disordered development, and early attachment difficulties may occur. If these are severe enough, continues Greenspan, 'they may form the basis for an ongoing defect in the baby's capacity to form affective human relationships and to form the basic personality structures and functions that depend on the internal organization of human experience' (p.749). The dyad art therapy experience is structured to symbolically re-create the early attachment stage. When the parent and the child are working together on the same art activities, the non-differentiation of self-object is re-created. The activities are designed to begin with a close, non-differentiated art statement and then to move on to a product that is conducive to individual and also collective interactions. Now we can observe cooperation. Then we can see movement towards free play or, for older preschoolers, separation from the parent, that allows for self-object differentiation.

The art therapist must understand the necessity of introducing media that have built-in limits in order to create a framework that will contain

the group. The materials chosen for the production of the artwork should be simple enough for the delayed child to participate in, yet versatile enough for the advanced child to elaborate upon. The art therapist must prevent chaotic discharge by the manner in which the materials are presented. Dyad art therapy offers, in a protective framework, a variety of cause-and-effect experiences and assists in the negotiation of functional emotional stages. The therapist reading this chapter will have noted that I am primarily focusing on very early stages of development; this is because it is the early stages that may not have been negotiated, due to the child's or the mother's physical or emotional health. Although we are working with children around 18 months to six years, we are still concerned with what needed to happen in the beginning when they were infants (zero to three).

At around 18 to 24 months, the baby begins to use symbols or emotional ideas that the parent may comprehend; Greenspan (1992) calls this stage 'shared meanings.' It is the stage of pretend play. The baby pretends to eat and drink or give the parent a cup of coffee. The child who may seem to have negotiated the previous two levels well may present difficulties with this level because of fears and fantasies. When is something pretend, and when is it reality? During the dyad art therapy, the parent may or may not intervene regarding the child's fears or dreams. It becomes very evident when it is discovered that the parent's own fears were left unresolved. The therapist can, through the art activities and materials, help the parent with reality testing, as making mistakes and taking chances on paper with a two-year-old may not appear to be threatening.

This shared meaning stage occurs when the activity and the media gain meaning, and there emerges a verbalization of the interaction. At this stage, the child may tolerate being away from the parent and no longer requires as much direct physical contact. Because the dyad intervention is very close and intensive, dyad art therapy is scheduled for only one half hour at the beginning of the group. The child's connection with the caregiver may now begin to be realized across space, without the need for physical contact, affording the child emotional communication with glances, vocalizations, and affective gestures. Moreover, during  the free play portion of the group intervention (for 18-month- to three-

-year-olds), and during the separation phase for the three to six-year-old groups and kindergarten class, the therapist can monitor the child's communication patterns. Greenspan (1992) reminds us that at this stage it is possible to recognize the relationship. Ego functions include pleasure, dependency, assertiveness, and aggression. At this stage the child is able to distinguish which is part of himself and part of the other, usually the parent: the 'me-not-me' experience. The child therefore begins to be responsible for part of the interactions, their initiation and the response to them. They also begin to develop their own affect patterns that include self-object patterns. Sensory organization built on solid attachment leads to the development of the capacity for cause-and-effect communication. Greenspan (1992) explains that a complex sense of self begins to develop around 9 to 18 months; it is at this stage, therefore, that the art therapist begins with proximal contact in order to achieve close contact between parent and child.

The next activity in the sequence is free play or, with adjunct therapy, separation from the parent, and here the distal modes of communication may be observed. In order to piece together the many cause-and-effect units of experience, there are many affects to organize: pleasure, assertiveness, curiosity, and dependency. You may observe a child who appears shy, sitting close to or leaning on his parent. During free play, this child may get down when he is feeling secure in the situation, and begin to play with toys, become overly confident and begin leave the area. When the parent admonishes the child with voice or look, he may protest, may or may not easily return and remain close to his parent to play or whine, tantrum, and crawl into his caregiver's lap. Here we have a demonstration of pleasure, dependency, assertiveness, and aggression and a need for closeness to the parent.

Ego organization, which includes differentiation from the parent may be characterized by an integration of impulsive behavioral patterns into relatively complete functional behavior. However, Greenspan reminds us that, unfortunate as it may seem, the children we work with in clinical settings may have ego functions characterized by self-object fragmentation: the child does not readily identify what is 'me-not-me.' Self-object proximal urgency is evident: the infant needs to be close to the mother in order to feel secure. The child begins to conceptualize,

concretize and polarize his affect. Negative, aggressive, dependent and avoidant patterns of behavior may develop between the child and the parent. The latter may include withdrawal, avoidance, rejection, somatic differentiation, and recognition of the parent. A child who is not able to incorporate certain sensory experiences as part of his early cognitive and affective abstracting abilities may evidence a very early restriction in how his senses process information. During this stage of development, the child should be able to rely not only on being close to his caregiver, but also on his ability to access him/her from a distance. 'The youngster who has difficulty in using his distal modes to remain in contact with the primary caregiver may need more proximal contact' (Greenspan 1992, p.754).

The art therapist may at times observe the process referred to by Greenspan as 'representational differentiation,' or 'emotional thinking.' This process begins between the ages of two and a half to approximately five years old. At this time, the child begins to see connections between images, representations, or symbols. They begin to have a sense of time. This ability is critical for limit setting and impulse control. The child is able to think 'If I do this now, Mother (or Father, or whomever) will be angry with me.' This capacity is important as it also helps the child to understand that even though the parent is not in the same room, she has not disappeared. At this stage, one expects that the four-year-old will have an integration of the idea and the emotion. When the child is able to use words, he becomes able to form an internal picture of his mother. He now relies on the word and the picture to convey certain internal feeling states such as security. During the dyad art therapy intervention, the child may make a kinetic scribble and describe it as 'daddy gone,' and the mother may interpret it as 'Yes, daddy went on an airplane this morning.' The artwork may then be used to discuss the child's sad feelings and the mother's feelings at the spouse's departure. The artwork then becomes a transitional object, which the infant carries home and displays, thus keeping 'daddy' present in the outside world as well as in the child's inside world.

Now we begin to see mental representations that are projected, through the child's art statement. Scribbles become cars, grandparents, daddy, monsters, dinosaurs, scary witches, etc. The dyad may begin to

create a story about what is happening in the image. When representation capacity has been developed, the child begins to draw primitive human figures. At first it may be accidental, but then he becomes able to repeat it and purposefully draw it, thereby gaining a lot of pleasure from the experience. The therapist may intervene, if the parent has not responded to the scribble drawing, by pointing out to the parent the emergence of a human figure. Greenspan (1992) postulates that during this stage 'a self-object relationship is characterized by a representational self-object. Ego organization, differentiation, and integration are characterized by an elevation of functional behavioral self-object patterns to multi-sensory drive-affect invested symbols of interpersonal and interactive experiences (mental representations)' (p.755). The art therapist begins to observe that the child can draw scribbles or 'tadpole' people onto which the child projects the roles of self, mother, father, sister, brother, etc. even if not present. During the free play portion, the therapist will observe the child's blossoming abilities to create scenarios, and to pretend play, rather than rote repetitive playing with the toys (e.g. instead of just rolling the car back and forth, the child is able to say the car is 'getting gas' or 'going to work' etc.). This is a stage when the child who has acquired language skills can name his feelings rather than act them out. Greenspan (1992) tells us that 'the representational capacity also provides higher-level organizations. These include empathy, consistent love (object constancy), a love for self and others that is stable over time and survives separation and affect storms such as anger, and later on the ability to experience loss, sadness, and guilt' (p.755).

The art therapist will be able to distinguish within the child two levels of the representational mode: the child will be able to *label* his pictures, and *describe* the objects he has drawn. The scribble drawing can now become a monster, a pet, or even a loved one, and he can now play out a scene with two cars bumping or two animals growling at each other. In his free play he may elaborate a pretend birthday party with cake, songs, and gifts, serving drinks and cookies to all those present and imagined to be present. His ability to symbolize will become apparent in his art and in his free play. In this dyad work, you will be able to observe the parent who is able to encourage the elaboration and you will note a wide range of affective themes, including dependency, pleasure, assertiveness, curiosity,

aggression, self-limitation, and even empathy and love. A child who experiences delays in this area may grow to be impulsive, aggressive, or withdrawn. Some children will suffer delays in sequencing their perceptions. Therefore, a repetition of the rituals of the dyad art therapy interventions becomes essential in order to help the dyad resolve the emotional thinking or representational differentiation.

When working with infants and preschoolers, the therapist must be informed and consider all factors: genetic predispositions, dynamics of the family, affect, impulsiveness, etc. When the child begins to play out events the observing therapist must be aware of what is in the past, in the present, and whether the child is able to differentiate make believe and reality. Greenspan (1992) helps us to understand that 'For the child to meet the challenges of organizing and differentiating his internal world according to self and other, inside and outside, dimensions of time and space and affective valence, he is, in part, dependent on the integrity of the sensory organization that underlies his experiential world' (p.761). He elaborated the functional emotional stages, classifying the child's abilities in the areas of: attention, engagement, participation in two-way pre-symbolic gestural communication, organization of chains of two-way communication, synthesizing an emerging pre-representational organization of self and other, representation of affective experience (pretend play etc.), and the creation of representational (symbolic) categories. These abilities form the foundation for such basic personality functions as reality testing, impulse control, self-other representational differentiation, affect labeling and discrimination, stable mood, and a sense of time and space that allows for logical planning. These are the stages that the art therapist must take into consideration when planning dyadic interventions. They must be kept in mind when observing parent–child interactions or when determining the problem.

During the dyad art therapy session, one looks at the range of emotional themes organized. Can the child or the parent play out only dependency themes or aggressive ones? Do minor stresses cause the child or the parent to lose their ability to represent, interact, engage, or attend? The art therapist must therefore be aware of the importance of a stable framework from which to work, one that will not collude with unhealthy family dynamics, but will be stable enough to allow changes to happen.

(For example, the parents are advised that after clean up it is snack the child does not want to sit quietly and eat, he cannot return to play is indicating that he is ready to leave.) This limit must be emphasized a the beginning of the session, so that it will not seem punitive to the parent who cannot control their child, when the therapist must enforce it. In this manner the therapist can help the child with his task of differentiating self and other, inner and outer, and space and time. It takes only one or two sessions for the child and the parent to understand the concept. Nevertheless, 'anxiety and conflict now tend to play a new role earlier than previously thought. Conflicts between self-object representations and external expectations can also occur' (Greenspan 1992, p.765).

The mental health professional working with infant and preschool populations, must keep in mind an age-appropriate theoretical framework when designing interventions. Since the child's sensory capacity, internalization, and mental representations occur in stages, it becomes necessary to symbolically re-create these stages using metaphor and rituals for sensory stimulation and internalization in order to strengthen the emotional ties within the dyad.

*Figure 15: Father and child play going to visit grandmother, in this sensory emotional thinking experience.*

CHAPTER 4

# The Art Therapy
# Attachment Metaphor

In this chapter, I will outline group work with dyads, and describe how
the activities and materials chosen must be developed with due
consideration for the age and developmental level of the child to
encourage positive communication between parent and child. I will focus
on the significance of creating ritualistic repetitions and the importance
of consistency in the opening and closure of the art therapy intervention.
I will include examples of how this intervention is applicable with school
age children and their parents.

When intervening with the infant population (18 to 30 months old) a
change has been made that is completely different from our art therapy
training. The infants and their parents remove the artwork from the wall
and carry it home with them. The artwork becomes a transitional object
containing elements of the parent and the child and of the therapeutic
experience. We encourage the parents to allow the child to be the one
who physically carries the artwork home even though they may want to
do so themselves. When they come back the following week, we are often
told that the artwork has been put on the fridge or their child's bedroom
door. The children like to keep it nearby, and often refer to it during the
week. The artwork may then become the anticipated visible expression of
the child's internalizations.

It will become obvious to the art therapist preparing to work with
infants, preschool children and their parents that dyad work is based on
symbols and rituals. This is the groundwork of the art therapy metaphor
in this intervention. Therefore I am clarifying these concepts. First, the

68

*Merriam Webster Ninth New Collegiate Dictionary* (1983) meaning of 'symbol' is something that stands for something else: symbolism as 'the art or practice of using symbols, especially by investing things with a symbolic meaning or by expressing the invisible or intangible by means of visible or sensuous representations as artistic imitation or invention. The symbol is a method of revealing or suggesting immaterial ideal, or otherwise intangible truths or states.' In *A Dictionary of Symbols* (Cirlot 1971), he considers 'the symbol to be "a precise and crystallized means of expression", corresponding in essence to the inner life (intensive and qualitative) in opposition to the external world' (p.xxix). In dyad art therapy, the materials, the process and the art product are meant to symbolize the earliest parent–child, non-verbal communication.

The therapist uses materials to re-create symbolically an early mother–child interaction. Non-traditional materials, such as cornstarch, flour, and jelly powder are familiar and edible. It is important that all material used with infants be edible, as they may put them in their mouths. The cornstarch reminds the parents of their diapering experiences; they refer to the cornstarch as being like the baby powder. The softness and smoothness of the material symbolizes the softness and smoothness of their babies' skin. Usually a pleasurable mother and child interaction, the parents comment on the softness, how it squeaks when you squeeze it in your hands, they laugh and play with it and may tell their child how they played with them as babies. Or they may tell stories that their mothers told them about being a baby. Since, theoretically, the falling in love stage is a stage of attachment, we hope that the symbolism of the cornstarch will ignite the early memories of first love. When we mix the cornstarch with water, it becomes muddy and is often referred to as 'clean mud.' The cornstarch and water material, called 'goop' is a paradox: it is wet yet dry. It is as paradoxical as the intervention that at times seems to contradict itself: it is messy yet clean, at the same time it re-creates an experience of early childhood in a situation far removed from that early experience. It does not seem to make sense, yet it does, and it becomes as mysterious to the parents as to the children. On the other hand, the flour, food coloring and water, in play-dough making, symbolized food and feeding situations. The jelly powder and spices such as cinnamon brought back memories of food that the parents make or

that their parents made for them as children. This material is placed in easily handled bottles such as salt or spice shakers. The parents and the children shake material out onto the collage or the painting. This shaking activity resembles the rattle that the baby loves to shake. It is simple for the infants and the parents enjoy joining them in shaking, just as an adult picks up a rattle when interacting with a baby. The shakers are produced by the therapist when she notices that the child is not engaging with his parent or with the activity. Just as with a baby one picks up the rattle to get his attention, the therapist models the shaking to the parent and gives both the parent and the child the symbolic rattle.

Mixing flour, salt and water is usually non-threatening and these ingredients contain many symbols. Flour symbolizes germination and growth, and making food, therefore feeding. Salt, among many things, symbolizes life, and water is associated with the mother and birth. It is the source of all life. Even the food coloring is used to symbolize diversity. In the use of these non-traditional materials, the therapist allows the child and the mother to experience turn-taking, and cooperation through mixing and making a material that is their own. They have not purchased it at the store, they have made it. It contains their interactions and the essence of the group. It also becomes a transitional object, as they allow themselves to create food such as pizza or cookies, or they can express anger or aggression, by pinching, pounding and cutting it. Or it becomes a playful imaginary material making snakes, dinosaurs, and monsters. The non-traditional materials help the parent to return to a childlike state, in an acceptable manner.

Sandpaper and chalk are other symbolic materials: the sand and the chalk are from the earth, but their texture and quality stand for impermanence, therefore this activity may represent the separation stage. Boxes and trays are used as containers in a variety of manners. They are used to create non-verbal boundaries that will contain the impulsive actions of the child. They are used to contain feelings and emotions expressed by both the child and the parent. They are also used as understructures of sculptures. Tape, string and ribbons for attaching materials are symbolic of the parent–child attachment. The materials and activities are not presented in a specific order. In this intervention, we are working on a variety of levels. It is only during the work with the group

or the individual dyads that the therapist will know which intervention to present, or to create.

The conventional art materials also carry much symbolic meaning. The paper or ground is firmly attached to the working table, then to the wall by the dyad, forming the secure base. Crayons, felt-tip markers and paint brushes become an extension of the fingers, and thus allow for separation from the paper. The fluidity of the liquid paint, which may be poured from smaller bottles that can be easily manipulated by both the parent and the child, may symbolize the milk from breast or bottle. The bottles of paint then represent the baby feeding bottle. It is always interesting to see even the youngest child being able to pour out the paint exercising control, and to observe other children, parents and even older children needing to empty the entire bottle of paint into a tray, and even overflowing the tray. In their pouring the art therapist can evaluate the emptiness or neediness of the client. The dabbers are also symbolic of the baby bottle, and some clients manage to get the paint out with very gentle dabs, while others become aggressive with the dabber bottle, causing the paint to splash and saturate the paper. Finger painting on mirror-like aluminum foil becomes a mirroring experience and pulling prints creates a distance from the art making experience. Clay, symbolizing earth, is easily manipulated by the preschool child, and often produces projections from the adult. We can provide it to the group as a non-directed or as a directed experience. The clay is presented to each dyad in the group in two balls, placed on an attached paper in front of each. It can be torn, pounded, pinched or cut. Or the therapist might ask for symbolic imagery, such as making a nest, or a container and placing something inside or making an animal family. The symbolism of the clay imagery is unlimited.

Other materials that I make use of are plaster of Paris bandage material and papier-mâché. Both create a strong solid covering, both can be painted, each has a different symbolic meaning. The plaster of Paris activity symbolizes reparation and healing. Cutting the bandages into small pieces symbolizes the cutting away of painful experiences. The water used to resolve the plaster is warm and soothing, rubbing the plaster bandage material also has a soothing effect. The bandages are used to cover an understructure, which the dyad has made and attached

together. The dyad applies a covering paint, and names the sculpture. While the papier-mâché activity entails tearing paper, similar to the cutting away, it is also soothing as it is dipped into the water, more symbolic of an activity creating a strong outer surface, such as a mask. It does not have the healing effect of the plaster, but the effect of creating something new, of starting over. The art therapist must guide the clients through the symbolic materials and symbolic art productions.

The ritualistic aspects of this intervention are important. The infant and preschoolers respond well to repetitive rituals. The repetitions offer stability and predictability. Therefore, the room is set out in a predictable manner. The chairs around the table hold the adult and child aprons in the same manner each session. The child knows immediately where he will sit and where his parent will sit. The children are separated with a parent on each side to offer containment of impulsive behavior. The activity for the session is placed on the table; the paper is taped to the table in front of each dyad sitting position. The children are asked to wait with their hands on their laps (on their knees). The sessions start quickly, as the children are impatient. The sessions end with the group sharing their experience with each other, telling stories, and often helping their child tell a story, pick out a color or shape, and say a few words about his/her work.

As the art therapist views the work, she keeps in mind the interactions that occurred while the work was being done, how the material was used to symbolically represent the relationship and the amount of personal space occupied by the child or by the parent. Also, the intensity of the media application, the amount of energy portrayed, whether the picture looks full of life, or seems depleted of color and movement. The art therapists looks at how the work is glued to the paper in the collage, and whether some of the pieces are falling out of the boundaries of the work. In the storytelling she can note who in the family has been included, who has been left out; how much of the work becomes the parent's possession, and how much is the child's. Are there obvious projections onto the child by the parent? In the artwork she can note the over working, the impoverishment or the richness of the production. During the process the art therapist notes whether there is engagement and communication, shared emotional contact, enjoyment, and loving.

## Engagement and communication in group work

The art therapy intervention is designed to promote reciprocal non-verbal and verbal communication between the child and the parent. The parent's gestural and verbal communications must be clear and at the child's developmental level. The child responds to the parent by staying within unspoken but clearly defined limits. Greenspan tells us that 'the core relationship problem may be that the gestural communication was never negotiated. For example, most children learn to comprehend limits from gestures, not from words... Two-way communication establishes very important behavioral parameters' (1992, pp.7–8). In art therapy we address gestural communication to help the child comprehend limits – and to assist the parent who is unable to set limits – in order to avoid destructive, ego dystonic chaotic discharge which produces the out of control behaviors. Since art therapy involves non-verbal expression it is therefore important that the art making process be safe; therefore, limits must be built into the activity in order to eliminate, as much as possible, the verbal interventions and directions of the parent.

With this aim in mind, there should be small quantities of each material provided; if the child wishes to use it all, he may. A tray may be used to set the limits so that the child does not paint on the table. Small containers such as jar lids are used to hold any water or paint to avoid spilling, and brushes that are in good working condition, not too small and with appropriate length of handles, are supplied. Ensure all markers are in good working order and the art ground (paper, cardboard etc.) is secured to the tray or table. The parent participates with the child by following the child's scribbles, smearing, mixing, and mark making. At this stage, the parent has a tendency to teach without engaging. Therefore, the materials must look inviting, requiring no instructions from the therapist. Material and media are presented so that dyads feel invited, as if to a banquet. Since we are aiming to bring the parent to play and follow the child's lead, esthetics of presentation are necessary.

Other interventions are designed to achieve group cohesion, engagement, and two-way communicating. Turn-taking activities, with both the child and the parent taking turns putting non-threatening food-like materials into a large common group container, work to enhance the cohesion of the dyad and give the small child a place to

practice sharing and turn-taking with his peers. When turn-taking is successfully achieved with the parent, we find that it can be successfully achieved in cooperative play. An activity called 'goop,' using cornstarch and water, has a similar effect when the dyad pours it into each others' hands as a turn-taking, touching and sharing activity. Another activity of painting together further promotes group cohesion: the therapist covers the table with brown craft paper, with the dyads cooperating in painting a mural. In order to address aggressive behavior in a non-verbal manner, the therapist will introduce therapeutic activities that allow for banging, thumping, smashing, and other rough handling of the materials by both the parent and the child (play-dough, clay, dabbers, and large, hard bristled brushes are some recommended materials for this). The therapist must always keep in mind the strength of the therapeutic framework, in order to allow for the expression of angry feelings by both the child and the parent. Ego growth may be achieved through appropriately expressed or sublimated repressed or negative feelings.

The following art therapy group or individual dyad work examples are based on years of clinical experience with this population. They are a composite of the types of problems presented. I am attempting to focus on the effects of the intervention not on particular clients. They are not case studies.

*Figure 16: Engaging and communicating in painting their home, at the easel.*

*Example No. 1: Collage*

A group may have up to six dyads, in this example four boys and two girls, (there always seem to be more boys) ranging in age from 18 to 30 months. They are in this group for a variety of problems that have led to difficulties in parent–child communication. Some of the attachment difficulties stem from over or under-involved parenting, and children that have had difficulty in self-regulation since birth. Carl is an 18 month cautious, sullen child. He has had a sleep problem since birth. He presents himself as oppositional and helpless. His mother has been on extended maternity leave and at his beck and call. She is depressed and exhausted, as is Carl's father. Mother wants to help her child separate from her to attend a day care since she will return to work shortly.

The art therapist has chosen a facilitating activity that also acts as an assessment of the group's parent–child interactions. Carl refuses to put on an apron; he sits before the self-adhesive ground that is firmly attached to the table and compliantly waits for someone to do the activity for him. His mother gingerly picks up a piece of paper from the pile of various shapes, colors, and kinds of paper in the middle of the table, and places it on the prepared surface. There is no enthusiasm. There is no eye contact, no smile, and no verbal communications. The child continues to sit and he begins to look as if he will act-up. His mother continues adding paper without engaging her child. The therapist intervenes by approaching the dyad; she picks up an interesting piece of transparent colored paper, and plays a peek-a-boo game with Carl's mother and then with Carl, who responds with a giggle. She gives the paper to mother who models the therapist's interaction. Then together they proceed to choose a spot, on the pre-glued surface, to place this fun paper. The therapist encourages the mother to rub the paper and the child accompanies his mother in this action. In this manner, the non-verbal communication-interaction is completed.

When the therapist notices that Carl and his group friends are getting fidgety, she introduces shakers of jelly powder, cinnamon, rice, etc. The toddlers love to shake out things. The parents comment on the delicious odors. Carl, who is an observer, decides this looks like fun and points to one of the shakers. His mother is so happy to see her child initiating something, joins him and they engage in shaking, and enjoying the

pleasant odor. When the child indicates 'all done,' they happily remove the paper from the table, choose a place on the wall at the child's level, and attach their work of art. Carl then moves away from his mother to the sandbox. The therapist brings mother a chair so that she can sit near and be available to play with him. When each child is done with the activity and all the children have moved to the play section of the room, the mothers share experiences and concerns while providing closeness and attention to their child.

*Figure 17: Attaching objects to make a complete picture.*

## *Example No. 2: Dot art*

The children in this group have an age range from 36 to 48 months. When the dyads arrive in the room they find that the ground on which they will work is not rectangular, the therapist may choose to have them work on odd-shaped paper such as a circle, triangle, oval etc. The dyad is presented with a variety of large paint dabbers (resembling Bingo markers) to use on glossy paper or on absorbent construction paper, whichever the art therapist feels they are ready to experience. The parent is encouraged to show the child how to bang on the paper with the paint dabbers. Many games may be invented as the child and parent aggressively attack the paper. When one of them realizes that the dabbers can be moved smoothly on the shiny paper, or that the construction paper acts as a blotter, other interactions happen. The dyad often laughs at the

splashes that occur, or the parent has an angry reaction. The parents at times get mad at the therapist because of the mess, or others ask where the material can be bought so they can do this at home. The result is a colorful artwork that is attached to the wall to dry, and be referred to at any time during the rest of the session.

Veronika is a 36-month-old girl who refuses to speak. She understands English and speaks fluently in her (foreign) mother tongue, but often refuses to speak even to her parents. She is oppositional, does not sleep well, and has temper tantrums regularly. Her mother who is pregnant, is exasperated by her seeming helplessness and her father often accompanies her to the group. Veronika takes a long time to participate in the art activity; she is usually clinging to her parent. She does not like to get her hands dirty. She acts as though she were a princess. However, she communicates, although very gingerly, in a non-verbal manner. She watches her peers dab with the markers. The therapist has asked her father to do the activity at the level of the other children in the group and not to coax Veronika into participating. She observes her father having fun and she decides to hold one of the dabbers. Then she takes one in each hand and begins making marks on the paper, banging rapidly and with vigor. She quickly covers the paper and asks her father for another one. She proudly assists her father in attaching both papers to the wall. Now the dyad appears relaxed.

In this three-year-old group, the parents leave the room after the dyad art therapy intervention. Because Veronika does not separate from her father readily, the group therapist asks her father to stay in the room for a while, but to sit back and simply observe. After a while, she plays in the doll corner, feeding a baby (as if practicing for the arrival of her sibling), always keeping her father in view. With direction from the group therapist, he tells her he must leave the room for a short while and that he will be in the waiting room, and she lets him go. At snack time, she eats a cookie and drinks some juice; she does not oppose being dressed by the group therapist. She leaves to meet her father in the waiting room. It takes several weeks before she allows father to leave with the rest of the parents at the end of the art therapy intervention. She begins to say one or two words. She chooses to use the art therapy session to release her anger, banging down with the paintbrushes, punching the clay, etc. She allows

herself to get her hands dirty. The mother reports that at home she is becoming more cooperative. She is being registered in a pre-kindergarten program.

*Figure 18: Dot art, with a removable cut-out of a tree. A surprise for the three-year-old. And an enjoyable, noisy and pounding interaction between father and child.*

The three-year-old child may be beginning to see connections between images, representations, or symbols. This ability is critical for limit-setting and impulse control. At this point, when the activity is over, a child three or older usually can easily separate from his parent, secure in the knowledge that the parent will return. He has begun to conceptualize a sense of space and distance; of what is 'me,' and what is 'not-me.' 'When the infant learns to use words and can form an internal picture of his mother,' Greenspan tells us, 'he now relies on his word and his picture to convey certain internal feeling states such as security, fears and fantasies' (1992, p.10). The child now has at his disposal more than one means of communicating.

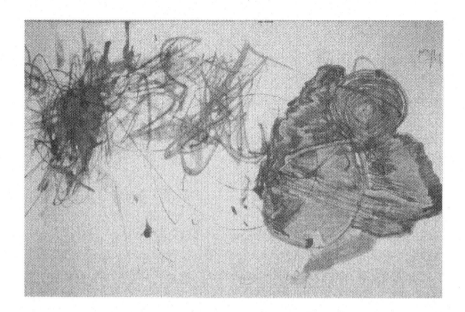

*Figure 19: Following the child's lead and scribbling at a 25-month-old level may be harder than you imagine it to be.*

## Example No. 3: Play-dough making

The parents and the children participate in this intervention by putting flour, salt, water, and food coloring into a large round container. The turn-taking is then elaborated by sharing the materials and container with the next dyad who add to the contents. The group, all equipped with wooden spoons, then move on to mixing, kneading, playing with the material, and sharing the finished product. It is a symbolic feeding intervention, with the dyads making cookies and pizza, etc. with the colored dough. The parents share past pleasant experiences of baking with their mother or father or accidents which they caused to occur when they were children. They sometimes share that they were not allowed to help with food making. The parents from other cultures tell how kneading is done in their country and this contribution appears to help them to fit in. The parents gain the ability of engaging their very small child in squeezing, pushing, and manipulating the dough. At the end of the activity, each dyad in the 18 to 30 month group puts the play-dough into a self-locking plastic bag and brings the dough, which they made

together, home. With the three to six-year-old preschoolers, the parent and the child place the play-dough into a container, and place it in the kitchen corner. Thus during the free play portion of the play therapy, the child may decide to recapture the pleasant moments he had with his parent, by playing with this dough.

Salima is a 48-month-old girl of North African parentage. She does not yet speak English and her mother is just learning the language. Salima presents with aggressive, oppositional and hyperactive behaviors. She cannot tolerate transitions without a temper tantrum. She has been referred to the clinic by the day care and by the family doctor. It was hoped that the group experience would address the mother's feelings of isolation. Play-dough making begins by putting flour in a large round bowl. The flour is presented in a wide-mouth container with two one-cup scoops. Salima had great difficulty taking turns with her mother to put the flour in the bowl; she wants both scoops for herself. Control issues surface, mother is embarrassed. The therapist takes a handful of flour, places it in front of Salima, and makes some marks in the flour with her finger. Salima, distracted, gives up the scoop. Mother continues to make marks in the flour with Salima. A confrontation has been avoided, and they begin to interact positively.

The bowl and flour is passed around and every participant contributes to the bowl, symbolic of a communal feeding. Then the salt is passed around in a wide-mouth container with two half-cup scoops. The salt is said to be symbolic of fidelity and friendship (Cooper 1978). Salima, who has been observing her peers, is now able to comply and allow her mother to put in a scoop of salt. The therapist and all the participants mix the colored water with wooden spoons. The therapist asks the parents if they know how to knead dough, as she demonstrates the kneading process. Salima's mother indicates yes. The dough is passed to her for the first kneading; she feels that she can participate and smiles. The parents watch her, and in turn knead the dough. The dough is then cut in pieces by the therapist and is distributed to both parent and child. With the preschool children, the therapist cuts six large pieces, and places a wooden stick for the child to use to cut the dough. She then asks the child to share some of this dough with her parent. The parents are encouraged to follow the child's lead by pressing their fingers into the

play-dough, tearing, rolling, and pounding. Cookie cut-out shapes and rollers are provided. The therapist asks the dyads to reshape the dough in balls and Salima helps put the play-dough in the container, which will be placed in the play kitchen area. She ignores her mother's leaving, and with the help of the group therapist acknowledges her mother's departure. She moves to the free play area and begins to play in the kitchen. Before beginning to play, she goes to the puppet corner and gets a 'mommy' puppet, which she places close to her on the table. We now begin to observe how the child can use the puppet to represent her mother, a sign of the beginning of object permanence.

At this stage of shared meaning, the parent and the child can participate in the creation of a scenario or objects, which they can use to invent stories together. In the artwork or with the play-dough, they can make representations of snakes and monsters, choo-choo trains, etc. This core process involves the level of shared meaning that may not have been resolved by 18 to 24 months, when the infant is learning to use representations (symbols and emotional ideas or perceptions) to comprehend their world. In order to reinforce the shared meaning stage, the therapist may create a pond using circular play-dough in the center of the table and ask the group to add stones, snakes, worms or ducks. The whole group participates and each then tells their story. A child who has done well with shared meaning and engagement and gestural communication may have a problem with fears of monsters, strangers, etc. These same fears may be present in the parent. The material provided therefore must be non-threatening and familiar. We may re-introduce making play-dough at another session, to reinforce the symbol and the ritual. The materials and the process have now become familiar to the dyad. The mother and child mix the dry ingredients with their hands, providing a touching and soothing shared experience. We now begin to observe object permanence beginning to develop.

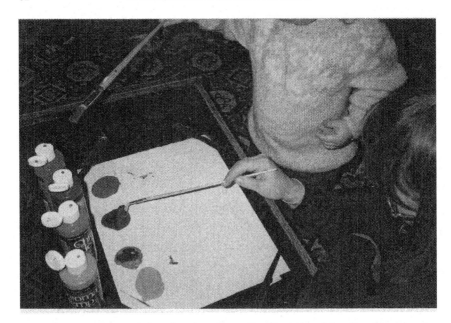

*Figure 20: Painting with long brushes allows for distancing from the paper.*

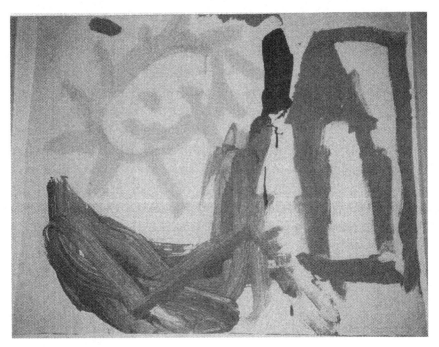

*Figure 21: Together they can paint and tell a story about their house and a nice time on a sunny day.*

## Example No. 4: Plate painting

In this session, the dyad is presented with a round aluminum plate containing the three primary colors, plus black and white. Two long-handled brushes and a third may be required for those who have not developed hand dominance and want to paint with both brushes; the ground (paper) is securely taped to the table. Both parent and child apply the paint from the plate palette. The parents are encouraged to mirror the child's strokes and to accompany the child's verbalizations of the product. During this process, the parents exchange good or bad experiences that they had painting on large surfaces or walls as children. The parents and children ritualistically place the finished product on the wall, wash, and go to free play or say goodbye. Some parents (in the infant group) ask to bring the mural home intact.

Andrew is a 20-month-old boy, who understands both French and English and who has begun to communicate verbally in both. He has feeding problems and is described as hypersensitive to textures. Andrew is an obsessive child who becomes over-involved with details. He worries about cleanliness and changes in routine. He is emotionally unavailable to his parents; he will first make known his needs or wants and may then decide to withdraw if they do not comply. After assuring himself that everything is in order, he begins the activities with his parent, becoming engaged, sharing with his parent as he communicates in his one or two word sentences. He becomes braver and braver at reaching out towards his peers to cover the whole paper with red paint, his favorite color.

The activity has provided him with a safe place to explore with his brush, while being close to mother who holds the plate palette; it allows him to make mistakes and a little mess in an acceptable manner, with mother's approval. After the ritual of placing his artwork on the wall, during the free play session Andrew has chosen blue paint and at the easel, he paints a scribble with long kinesthetic arm movements. He looks at his mother and says 'grandpapa.' Mother explains to the therapist that grandfather is away and that Andrew saw him take the airplane. Andrew brings the painting of his grandfather home, and mother reports the next week that he often went to the painting when he was missing his grandfather who lives with them.

*Figure 22: Plate painting.*

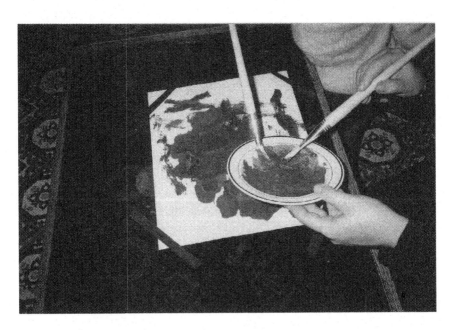

*Figure 22a: Providing a secure base, and a symbolic feeding situation, allows for non-verbal communication.*

*Example No. 5: Music, reading and movement*

In the parent–child interaction group, (18 to 30 months) the group activities include music, reading, and movement. Devin is 30 months old. He has attention deficit, and hyperactive behaviors and he has not yet acquired language. At the first session, he had a difficult time attending and sitting at the table. When he noticed the variety of shapes and colors of paper he became interested and cooperated with his mother in making a collage. During free play, he explored the toys appropriately, but would not pay attention at book reading, and exhibited tantrum behaviors during the music and singing portion. His interest revived when putting a doll in the sheet hammock for rock-a-bye baby; he also helped to rock. At the second session, he came and sat at the table willingly and participated in play-dough making, although he still had difficulty with story time and music. After several sessions of being held by his parent during reading and music time, he finally realized that he would not be allowed to play and run around freely. After a short break during the seasonal holidays, he participated in the art and all the other activities with enthusiasm. He listened and interacted with the therapist at story time. He sat on his mother's lap during music, and imitated the singing and clapping behaviors around him. He has begun to speak in single words. During free play, he was able to warn a peer that the pretend hot water would 'burn.' Devin's behavior greatly improved and his attention span began increasing.

The format of the sessions and the tight framework helped this child through the necessary developmental stages that he was unable to attain when left to his own scattered attention and hyperactive behaviors. The framework, which allows for proximal and distal communications, combined with the rituals and symbolic representations of the therapy allowed mother and child to begin to interact and communicate in an age-appropriate manner. At such times, it is tempting for the art therapist to allow the child to run about. However, it is important that the child, with the help of the parent, begins to understand and comply with the set limits. Only then will improvement in the behavior become evident. The parents have often commented that they attend another program in the community that is similar, but does not seem to have the same effect as our clinical group. I believe the difference is that in the clinical group we are

taking into consideration both the parent and the child. In the dyad art therapy group, both have the opportunity of expressing their own internal issues with a therapist trained to address them either verbally or non-verbally. In the community group, the room and equipment are similar; the process of the group is not as controlled as in a therapy group, and an educator or a parent may animate the group. The group has a social rather than a therapeutic program. However, we recommend that parents participate in the community group. In this manner, we are able to determine the lasting effects of our interventions.

*Example No. 6: Watercolor crayons*

*Figure 23: Providing just enough water for dipping prevents spilling and chaotic discharge. This limit provides containment and safety. The boy adds the blue line and states 'The snake is chasing Jack.' The mother accompanies him by repeating the statement and the line.*

Heidi is a 36-month-old East Indian girl whose mother feels isolated, away from her family and homeland. The languages spoken in the home are an Indian dialect, which Heidi speaks fluently, and English. Heidi, a

premature baby who suffered from some periods of apnea, now attends a French day care, where she is slowly acquiring her third language. She has a history of sleeping and feeding problems. Heidi is very difficult to engage; she freezes, clings to her mother and refuses to speak in any language. She looks very angry. This angry behavior does not appear to be a product of learning three languages, as she demonstrates it at home where she refuses to speak to her parents in the language in which she is fluent. Heidi is able to engage with her mother in the art activity and she has been able to follow the group agenda and rituals, however she refuses to speak even to her parent. During the watercolor crayon activity, she refused to look at her mother; she kept pushing her away, and taking all the crayons for herself. She looks angrily at the other children who are making scratching noises with their crayons.

The therapist acknowledges to Heidi that she did not want to share the crayons with mother, and gives mother another box of crayons, which Heidi wants to take, but is told by the therapist that these belong to her mother. The therapist asks Heidi where mother might draw on the paper. Heidi points to the corner of the paper. She uses the watercolor crayons aggressively. Mother copies her movements; Heidi laughs and shows mother that she can use more paper. After having expressed her anger appropriately with the media, she is able to tolerate the presence of her peers during free play and she enjoys the reading and music activities. Although she has always participated in rocking the dolls or other children in the exercise, at her last session she felt secure enough to be rocked by the group. Heidi's progress has been very slow. If there is a holiday break in the meetings, she regresses to her clingy behaviors. Her mother gained confidence in the group, and Heidi participates in a group in the center where mother is studying.

This type of child requires more interventions in order to prepare them for cooperation and attendance in kindergarten. Some of the mothers comment about a rise in their parenting skills and in their self-esteem. They may also wish that they had had such experiences as children.

In recent dyad work Eric, a 34-month-old boy, who with his mother, using watercolor crayons was able to produce a scribble that he called 'Jack.' He added a line to the scribble and said 'snake catching Jack.'

When his mother mirrored his mark with another line, he called it 'a bridge for Jack to run on.' In a simple scribble drawing, this dyad was able to create a story, and the scribble became a representation of his fear for a loved one, or for himself, a good example of emotional thinking in one not yet three years old.

### Example No. 7: Box sculpture

The following activity is one of the several therapeutic projects that take up to six sessions to complete. In this type of intervention, the child is helped in remembering what he was doing the last time he attended the session with his parent, which may help in strengthening abilities for mental representations. The dyads are active participants in planning their sculpture. They are asked to collect small boxes in the two weeks preceding the sculpture making. When the group arrives, they sit at the main table while the therapist gives instructions. Around the room, small tables have been set up, with a roll of masking tape on each. The dyad is asked to go to the pile of boxes and select one box each. They then choose a table where they can work together, away from the larger group. They will use this table each time they return to work on this sculpture. The next step is for the two to cooperate in taping the two boxes together. When this is complete, they return to the box pile and each chooses another box, which they will tape onto the first two. In this way, they are piecing objects together. Some dyads begin to see a particular shape happening, while others make abstract objects. Some of the dyads tape the boxes together very lightly, resulting in structures that tend to become undone or to fall apart. The therapist helps them to solidify their structure, by showing the parent where more tape is needed. Other dyads use tremendous amounts of tape and create a solid structure.

When the box sculptures are big enough, which takes approximately two sessions, the art therapist will introduce rolls of plaster bandage, scissors, and a shallow tray of water. They are asked to cut the bandages in small pieces that are easier to manage. The therapist may have to demonstrate how the parent can help a child who has difficulty cutting. Alternatively, she may suggest that the child hold the roll of plaster bandage, while the parent cuts. It is important to engage the child in this step. Otherwise, the child just sits, fidgets, moves, acts out and the parent

does all the work. After they have completed cutting the plaster bandage, the therapist shows them how to apply the bandage to the sculpture, the plastering sessions begin. The dyads work intensely. They must place the bandage on the sculpture and then gently rub it in place. At the end of each session, the unfinished pieces are placed at the back of the room, where they remain until the next session. When the children return to the group the following week, their sculptures are waiting for them on their worktables. The children begin to recognize them and ask, 'What will we do today on our sculpture?' When the plastering is done (after the third/fourth session), they are introduced to liquid paint and one paint brush each; they proceed to paint their sculpture. The sculpture comes to life, and even abstract ones begin to have recognizable shapes.

One dyad that had enjoyed taping boxes together with no design in mind, appreciating the abstract art, saw something else when they began painting it. The four-year-old boy, with serious aggressive behavior problems, told his mother 'It's the big bad wolf.' His mother agreed, and with the decorating material available, they completed the creation. Was he expressing his fears of his own aggression, was the dyad's aggression sublimated in the making of this sculpture? A distractible, active child, who presented with echolalia and was considered to be on the autistic spectrum, surprised his parent and the therapist when he saw the boxes and told his father that he wanted to build a space ship. The boy proceeded to choose the appropriate boxes and paper rolls and with the assistance of his parent began to tape these together, and constructed an impressive space vehicle with symmetrical accuracy. The construction of this sculpture kept him focused and communicative.

At the end of the project the dyad, if they have not already done so, are asked to give a name to their sculpture, and they gather around the main table to tell their peers stories about their sculpture. (The therapist may take a picture of the sculpture for the file.) The children take their sculptures home, and the play group therapist may place the pictures on the wall, to refer to as needed. Many of the parents report that the sculptures are kept in a special place; others see their children using them as toys, since the children make quite large objects like horses, trucks, castles, towers, boats, dinosaurs and space ships, or they are used as table centerpieces at the child's birthday.

During the weeks when the sculptures are in progress and the child and parent are working separately from the others, the therapist may observe behaviors that the child acts out at home with the parent, and which may not usually be demonstrated in a group. This gives the therapist the opportunity to intervene, or to meet with the parent at a later time to discuss the behavior. Some of the parents often enjoy allowing their fantasy to run wild and creating with their child wonderfully elaborate stories around the sculpture.

STAGES OF THE BOX SCULPTURE ACTIVITY

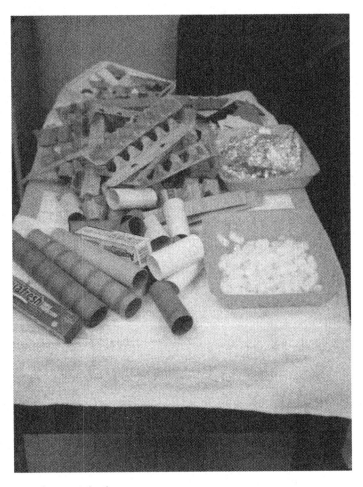

*Figure 24: The mateial pile.*

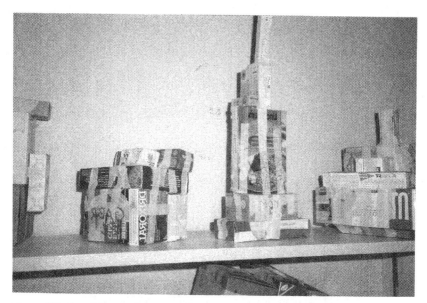

*Figure 25: Attaching the boxes together.*

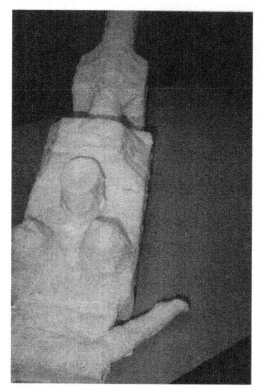

*Figure 26: Application of plaster bandage.*

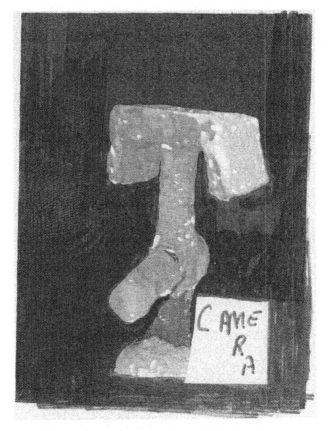

*Figure 27: Completed work, painted and titled.*

## *Example No. 8: Clay Hand-building*

This activity can be used with all the preschool children. They enjoy making clay art with their parents. It is also very successful with the older preschoolers, five to six-year-olds and those in kindergarten classes. The children and the parents enjoy pinching, pounding and rolling the clay material. They get pleasure from forming it into objects and creating stories around the objects. This is a group of six children five to six years old and their parent in the special kindergarten program. The children who do not function well in a group or in a kindergarten class may have symptoms of language disorders, aggressive behavior, attachment disorders, hyperactivity, or autistic spectrum disorders. During this session, the parent and child work on a 24" x 12" piece of cardboard

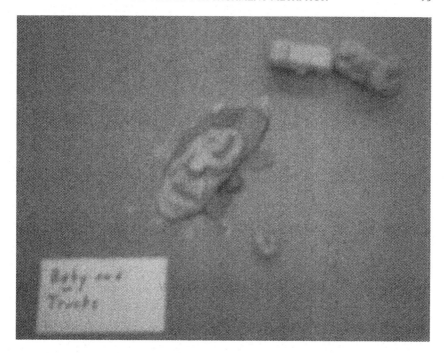

*Figure 28: Baby on a bed and trucks.*

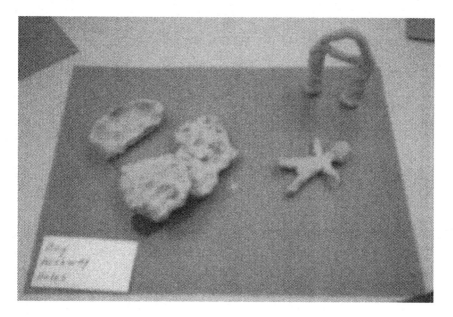

*Figure 28a: A boy, an archway, and holes. A non-directed clay activity.*

taped to a table, on which two balls of clay are placed. The clay is a powerful medium to assist in the expression of conscious thoughts and of unconscious impulses and content. This activity can be directed, such as: make a container and put some objects into it; make a nest and put inside what lives there. Or it can be left open as a non-directed activity: you can use the clay to make anything you like.

The group therapist, the classroom teacher, or an art therapy intern may accompany a child whose parent is unable to attend. The directive given by the art therapist in this session is as follows: 'With the clay create a family of animals.' They can be farm animals, jungle animals, prehistoric animals, pets or make-believe animals. The limits are often pushed, and one child asks to make several types of animals in his family. The directive is then repeated for clarification, since the child may be expressing the confusion of the parent or of the whole group. In this exercise, the therapist is using the animal family as a metaphor that may allow the dyad to express feelings of anxiety, separation, containment, rivalry, etc. During this process, the art therapist is focusing on the dyad's ability to engage in the activity. How will the dyad resolve problems that arise in the production? Is the parent able to follow the lead of the child? Is the parent able to contain the child? Does the dyad enjoy working together with this messy medium; can the dyad have fun?

This is the second time this group has had a clay intervention. A child who is working with the help of an art therapy intern begins by making a container like the one he had made with his mother the last time. Another child who, with his mother, is having difficulty arriving at a decision as to the types of animals they will make, also begins by making a container; this was a good past experience that he had with his mother. One boy is aggressively pounding the clay; his mother does not interact with him. Another boy is becoming quite active and the group therapist intervenes to quiet him down. The boy who demonstrates aggressive behavior decides to share with us the anxiety and sadness at the killing of a mother in a gorilla movie. His mother is able to engage him in making a large nest for this animal family they have now chosen to make. Feelings of separation anxiety and fear are being represented here, as well as the mother's ability to provide a safe nest for her family. He makes two baby

animals and places them in the nest. This may well represent the mother, or his home where he lives with his sibling.

Another boy and his mother have created an extended family of sleeping dragons, each with its own rock to lie on. He is having difficulty naming all the members of this extended family. This child has known more than one family, having experienced foster care separating him from his birth family. He names a 'dragon grandmother.' Is this a new family element for the caseworker to explore? All these dragons can do is sleep. Is he expressing his fear of what will happen if they awake? Another quiet boy has chosen to tell us of his losses through the creation of dogs representing his own dog, who has died, and another one of their dogs that was lost. This usually silent child speaks of this loss to his father in a very low voice and wonders if his dog is 'in heaven.' He asks his father's assistance in telling this painful story. He has only just begun speaking to people other than family members. Another father–child dyad tells us that they have created a turtle family, naming them after members of the child's family, including his two younger siblings. Although he has provided his turtle family with large quantities of food, he nonetheless smashes the baby turtle. This turtle family has been constructed without their shells, which provide protection as well as containment. This is a very important factor since this hyperactive child rarely experiences consistent limit-setting. The use of the animal metaphor helps the dyad to disguise the subject matter and allows a spontaneous expression of feelings and anxieties in the once-removed object. It also permits the parent to express their feelings and to share in the story that they will help their child tell.

With the three to four-year-old group, the art therapist provides the material and gives simple instructions on how to pinch, pound and roll the clay. They allow the dyad to make anything they want. The theme of the baby often recurs. In Figure 28, we see the trucks that were constructed, and the bed for the baby; the child had asked his mother to put a baby into the bed. Another baby theme is present in Figure 28a where the activity began with the parent making the arch. The three-year-old with fine motor delay was enjoying poking his fingers into the clay and the mother mirrored this poking game. Then the boy

asked his mother to make a boy who could 'walk in all the holes.' They each took hold of the clay boy, and went on an adventure to the moon.

## Example No. 9: Pretend aquarium

One activity that has proved very popular is the pretend aquarium. The parents report that the aquariums are kept in a special place and the children refer to them often. This activity is presented after a few sessions of therapy have taken place. It is one that must be carefully planned to take the developmental levels of the child into consideration. The child and parent are able to communicate and cooperate when they are rolling the white and blue paint that will represent the water. This activity may take up to five sessions to complete. The children return each week with a visual representation of the pretend aquarium, and are enthusiastic at making it. In the following sessions glue and sand, and sea shells (real sea shells or painted macaroni) are used.

Then the parents and the children create the seaweed and the fish, and whatever may be on the bottom of the aquarium. It is always a revelation to discover the types of fish a dyad will chose to make, and the types of things which may be found on the bottom of the aquarium. The fish may be mild goldfish, or vicious sharks, killer whales, electric eels, or they may be octopus. On the bottom of the aquariums we find sunken chests, crashed ships, skulls, treasures, mermaids, or just the sand. The box, the objects, the tactile process, the containment, and the plastic covering create a time of concentrated engagement. The aquarium appears to have a special appeal to both the child and the parent. It also develops the dyad's emotional thinking and representation.

Sometimes it happened that a child attended our program for more than one year. It is interesting to note that neither the parent nor the child seem to mind that they are repeating the same activity. They usually mention that they did this before, and they may even mention that they still have the other aquarium. When an activity is repeated it usually affords the child the opportunity to show his knowledge. He is able to understand the process and he is able to make changes in this production. It was interesting to note one dyad, who had in the previous aquarium placed two sunken ships at the bottom and sharp toothed, angry looking sharks swimming around. At the time, the dyad was having serious

communication problems, and the child had severe acting-out aggressive behaviors. One could deduce that their ships had collided and sank and they were about to be attacked by sharks. Although they were unable to confront their difficulties, they were able to verbalize the fate of the ships. The following year, they repeated the scenario of sunken ships in the aquarium, but above the ships swam a mermaid and friendly goldfish. The child's acting-out behavior had considerably improved. The dyad was able to express their desire to salvage the sunken ships. On a separate piece of paper, they drew the ships floating on the ocean and going on a voyage. The activity has permitted some reparation to take place and the resolution of some of their conflicts.

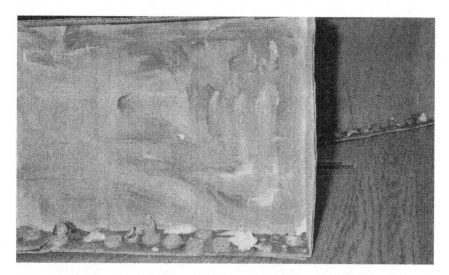

*Figure 28b: Moving from abstract concepts with clay to concrete concepts with boxes, sea shells and sand is an exercise in cognition.*

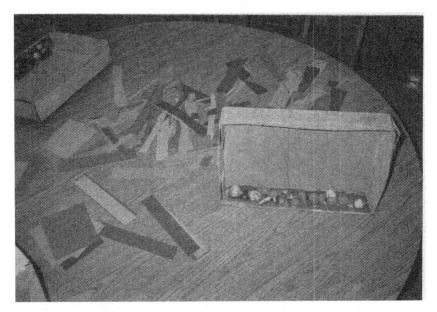

*Figure 28c: Painting, drawing, cutting and gluing objects into the container that provides safe, secure limits.*

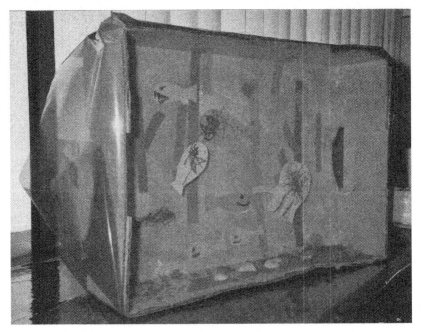

*Figure 28d: Making a pretend aquarium is a process that develops age-appropriate motor skills, imagination and memory.*

## Individual dyad art therapy interventions

The parent–child-dyad art therapy intervention can also be applied in individual work. At times, it is an adjunct therapy for a child who is involved in psychodynamic play group therapy treatment, or who is seen in family therapy by another therapist. However, it can be the primary therapy mode, with the therapist meeting with the parents on a regular basis. After the initial appointment, I often recommend that the parent follow the therapy along with the child. When working with the older child, who is having issues at home, it often removes the burden of responsibility from the child, who may be acting-out the family dynamics. In cases where children have been in foster care, parent–child-dyad work assists them in beginning to reconnect with their birth parents, or simply to express their feelings at being separated from their parents. It has also assisted the foster parent in developing a relationship with the child. It may also help a child who is having difficulties in a newly reconstituted family.

Parent–child-dyad art therapy is often recommended for hypersensitive children who demonstrate their difficulties by being intolerant of certain clothing, or are unable to eat certain foods. Since in this work I make use of a lot of tactile material, the infant who is hypersensitive is often more easily attracted to the material or activity if his parent is also participating in it. The therapist must never force the issue. In the beginning, provide shakers of material that the sensitive child can sprinkle onto the paint, or give the child a long handled brush to push the material around with. Later when the relationship with the child has been established, you can try painting with a toy car. It is also important to speak to the parent, advising them not to respond when the child *does* get his hands dirty. Sometimes they respond positively, and with pleasure, but this is enough for the child to withdraw. It is best to allow the child to explore the tactile material in very small steps. A child may present as clingy, or as not being able to separate from their parent even at bedtime. In many cases while helping the parent with the sleep problem, the added dyad art therapy provides a special, secure time with the parent each week. In families of more than one child, it is a privilege to have the mother or father to oneself. The therapeutic intervention may provide the necessary security the child will need to change his behavior.

In other cases, the mother may have suffered postpartum depression, or other physical difficulties. There may have been a long separation because of premature birth, illness of either the child or parent, or for social reasons. The parent–child-dyad work provides the transitional and secure base to allow the parent and child to reinforce or reestablish the emotional connection.

There are as many reasons as there are dyads; the common denominator of most clients is that communication and interaction between parent and child have been disrupted. Figures 29, 30, 30a and 30b, are examples of artwork produced by dyads with relationship problems. It is interesting to note that we may often see through the use of the material, the attachment difficulties. Attaching objects to a self-adhesive surface may not be as easy as one thinks. It has also been

*Figure 29: Attaching objects to a self-adhesive surface. Note, it often occurs that in cases of poor attachment, the streamers fall off the page.*

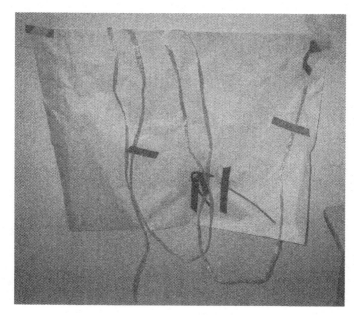

*Figure 30: Separation anxieties may be expressed when attempting to attach ribbon with colored tape to the paper.*

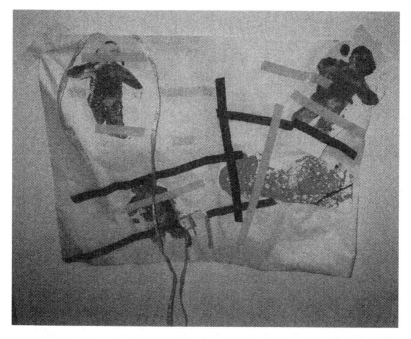

*Figure 30a: Prints of a boy and dinosaurs can be described as the family being attached to a sheet of paper with tape, ribbon and glue to hold them in place.*

*Figure 30b: Attaching string and pipe cleaners is also a challenge.*

noted that tape, glue and string are often the materials of choice with these clients. One of the main differences between individual dyad art therapy and group dyad art therapy is the format. In individual dyad art therapy, the mother and child can choose to do art, play with the toys, or sandbox. There is a wide variety of choices for them. The dyad activities are introduced when the therapist sees that the parent and child are unable to arrive at a mutually acceptable decision. The therapist is then able to offer an intervention that will engage them.

### Example No. 10: Multi-media project

In recent years, there have been a large number of immigrants and refugees to Canada. Many families suffer lengthy and perhaps painful separations. Here is an example of how parent–child-dyad art therapy helped to alleviate a child's suffering. I was asked by a refugee and immigration society to see Annie and her mother in order to facilitate the child's adjustment at the school and in her family. This child had been separated from her parents at age five and now at eight years of age, the family was reunited. Her parents reported that eight-year-old Annie was

acting like a baby at home and was not adjusting to the school and they did not understand why. We contracted for 20 sessions. Annie's parents were well-educated professionals who had been separated from their daughter just after her fourth birthday; they were skeptical about art therapy. Mother spoke two languages and communicated with me in French and with her daughter in their homeland tongue. The child did not speak with me. After several weeks of using a variety of materials, progress was slow as Annie kept rejecting her mother, and mother did not quite know how to engage her child. The theme of Annie's drawings were of large birds and angels with wings, as if she were working through the flight that her family had undertaken.

One day, when it seemed that the therapy was at a standstill, Annie decided that she wanted to build a house. She explained to her mother that she wanted to use the box, in which we had been keeping the artwork. I transferred the artwork to a folder, and using the box, tape, glue, plastic shelf paper, cardboard, crayons and paint, and with the help of her mother, Annie created a two storey rectangular house. The inside was decorated with the shelf paper and the outside was painted and adorned with balconies and windows as in the old country. This creation took several weeks. When it was completed, Annie brought three little figures from home, and told her mother that she wanted to make furniture to fit the 'mommy,' 'daddy,' and 'little girl' dolls. When the kitchen, bedrooms, and living room areas were decorated and fitted with furniture made from cardboard and plasticine, Annie enacted scenarios with the little figures. On another week, she took some colorful modeling clay and asked mother to make dishes. She then made gifts, a birthday cake with four candles, a few modeling clay friends, and a grandmother. Mother explained that Annie had been left behind with the grandmother. The little clay figurines, and the mother, father, and baby dolls had a birthday party complete with gifts, cake and candles and Annie asked mother to sing the birthday song. Mother reported that right after the celebration of Annie's fourth birthday she had had to leave her country. Therapy ended six weeks later.

Annie appeared to have reconnected with her painful past. She began to cooperate at home and to be attentive and participate at school. She was a bright child and was able to follow the class instructions, and to

*Figure 31: The house.*

*Figure 31a: The birthday party.*

learn French and English. Both her parents were amazed and grateful and spoke of their skepticism. In this example, the therapist made no verbal interventions, she observed and made available the required materials. The child, with the support of her mother and of the therapist, was able to return to the time of separation. Dyad art therapy had provided the secure setting where she was able to reconstruct the painful event, and perhaps begin to understand it. Her feelings of abandonment seemed to have been resolved, which allowed her to reconnect herself emotionally to her mother. With this stress resolved Annie was able to concentrate in school and master the foreign language.

## Example No. 11: Drawing with a variety of media and sand Play

It can happen at times that an art therapist is asked to work with children who are in the midst of parental disputes and they may be victims of turmoil, which they do not understand, and which they have not created. There are some cases where, because of charges, one of the parents is required to have supervised visits with the child, until the courts have made a pronouncement on the case.

Annette, a three and a half-year-old girl, was an only child caught up in the middle of a difficult separation and divorce. There had been a long break from one of the parents, whom she had seen only a few times in the past year. The couple were still very angry at one another and now Annette had to learn to adjust to joint custody, living half the time with each parent. She presented as a quiet, sad child, compliant and trying to please everyone. Although the child had been referred to me for individual therapy, after a few sessions I saw that dyad art therapy would be more effective. Since this was a case of joint custody, it was decided that we would begin five sessions with one parent and five sessions with the other. This facilitated the observation of Annette's relationship with each parent. These sessions permitted Annette to interact with each parent in a secure environment, without fear of admonishments from the other parent.

No matter which parent she was with, Annette was at first very defended and, with a variety of materials, kept her drawings lines and scribbles that she called a character from a television program. Repeatedly she drew this child with super powers. Her drawings,

although immature, were stereotypic, empty, containing little affect. Her mother was not willing to draw along with her and occupied her time with her own art productions. Her father did not understand the character, but resolved to watch the TV program. Neither parent could understand what was required of them. After several sessions that did not seem to be going anywhere, Annette discovered the sandbox. Here she found a variety of figures to manipulate, she was able to make castles, moats, have wars. Although somewhat resistant at first, her mother began playing with her daughter in this messy, muddy material. At times, they stopped to draw signs, or to add colored water to the river. Her father was interested in the variety of little soldiers available and together, she and her father developed different types of scenarios in the sand.

During the year of weekly parent–child therapy, Annette began pre-kindergarten, the father outfitted a room in his apartment for Annette, and both parents began to agree on the school and the school schedule. The following year Annette began to show serious signs of her trauma and emotional neediness. At the school, she was taking things. Individual therapy for Annette was resumed, with regular meeting with both parents. With the cooperation of the school and the parents a special time, with either parent was scheduled, as well as her involvement in school activities. With the added attention by both her parents on a regularly scheduled basis, the negative behavior disappeared. Annette did well in her following years of school, and the parents were able to develop a parenting relationship with each other, for the benefit of their child.

Parent–child-dyad art therapy has been the basis for supervised visitation when the child and the parent are unable to communicate during the special hour sometime in the month. It has helped develop a friendly relationship with the parent that the child does not know well, or the parent that has received negative comments from the other parent. After the first half hour of dyad art therapy the child and the parent have participated in a pleasant experience together. This forms the basis for other interactions and for enriching the relationship.

## *Example No. 12: The 'Goop' and muffins*

Mario, seven years, and his half brother were adopted children. Mario was referred to me as the mother felt that he was distant towards her and not as emotionally attached as his brother was. Both father and mother were concerned about their child's happiness. Mario had the choice of all the toys in the playroom, the sandbox and any art materials that he was inclined to work with. He was listless and very difficult to engage. Mother would observe him, but she had trouble getting involved with him. A variety of the interventions listed in this book were attempted with more or less success, until the 'goop' was introduced. Mario and his mother came to see me once a week, and every week Mario asked to make goop. He found great pleasure in manipulating this magical material. It was soft, yet solid, it was wet and yet dry. The tactile stimulation of the goop, being able to bury his mother's hands, touching each other in the bowl, spilling the material out on the table, adding color to it, pulling off prints from it, all seemed to contribute to strengthening the mother–child relationship. But just when I felt that the therapy was becoming effective, mother informed me that she had to leave for six weeks to be with her own mother who was undergoing surgery. She was going overseas and would bring the younger boy with her, but did not want to disturb Mario's schooling.

What a dilemma – I knew that the separation might have serious effects on Mario's emotional health. There was no other solution, mother would go and Mario would be with father. I asked mother if she could leave something meaningful for Mario. What was the favorite thing that she did for him? Mother remembered that he loved her muffins, which she baked daily. She agreed to make enough muffins, to be left in the freezer for her entire absence. Then during one of the sessions, she and Mario prepared a calendar. His father would help him to place a sticker on the calendar each night, thus making visual the abstract concept of mother and brother's return. Mother would leave 30 very small, individually wrapped gifts, that dad would give him each night. We hoped that in this way, along with phone calls, mother's presence would not be missed. It was agreed that Mario would continue to see me weekly, but this time with his father. Mario continued to choose making goop with his father, but the goop was now used to hide things in. He would

collect small toys, and bury them in the goop. At the end of the session Mario and his father would retrieve them and wash them off. One week Mario asked if the elephant could remain in the goop until next time. The goop would harden during the week, until it cracked and looked like a puzzle. He and his father would carefully remove the pieces, retrieve the elephant, add water to the goop, hide the elephant, and then proceed to draw pictures on a paper with felt-tip markers. The themes presented in the drawings were jungles, elephant mother and baby, and their favorite food: muffins. Therapy ended after mother's return. We had a family session and both parents were happy to report that the relationship had not deteriorated and that Mario was having positive interactions with his brother. They were playing goop at home as a family.

### Example No. 13: Collages of every type

Children who have suffered the experience of foster homes often show symptoms of emotional deprivation and attachment problems. They might over eat, steal, or run away from home or school. They do not trust, and may have difficulty making and keeping friends. They might also be aggressive. One such boy, Joshua, began to work with me when he was five years old. He had developmental delays, was overactive, over ate, ran away, and stole mostly food from lunch boxes. He had suffered four or five different foster homes during his short lifetime. I began work with him and his foster mother, as I did not want to add more anxiety by removing him to my office alone. They painted together, played with goop, made play-dough. With the play-dough he made food, hamburgers, cookies etc. which he would wrap up to bring home to his foster brothers and sisters. Alone with his foster mother his behavior was different, he was calm, quiet and polite.

It was interesting to notice that whenever his foster mother gave him a choice of activities Joshua chose to make kites. These kites had long pieces of string attached to them. He used tape of every color to hold things down on the kite; he used masking tape and glue. He liked to make sponge prints, cut them out and paste, tape or glue them onto his kite. These sponge prints represented Joshua's foster family. You will note in Figures 30, 30a and 30b his need to attach things and symbolically resolve his attachment. He was still having a problem with excessive

eating and making play-dough seemed to be one way in which he was able to symbolically feed his deprivation. It is an example of how a child will choose the materials to express his inner needs. Joshua had to attend a special school because of his aggressive behavior in class. He was lucky to have found foster parents who cared for him in spite of his acting-out.

## Example No. 14: Finger painting

Some of the children who have been referred to me by psychologists, who specialize in sleeping or eating disorders, may have problems with textures of clothing or food. These babies may have had a colicky beginning. Their language may not be well developed, and they may have delays in motor functioning. Their parents are usually quite tired, if the child's behavior continues to be difficult at 30 months old. These may be difficult children to engage. They are often demanding of a lot of attention, while at the same time rejecting it. After four years, Nelson had a new sibling to contend with, and he was aggressive towards her. His mother wondered why she had to participate in his therapy as she had such a busy schedule. However, she understood that this special time alone with him might help with their strained relationship. She really wanted help with his hypersensitivity and eating problems. As the sessions progressed, Nelson and his mother began to play with the messy finger paint. At first, Nelson would not touch it, and I noticed that his mother had an aversion to getting her hands messy. So, to begin with, they were given shakers of flour, jelly powder, spices, etc. to shake out onto the finger paint, which was made of white yogurt with food coloring, and placed on cardboard covered with aluminum foil and taped securely to the table. They were supplied with long-handled brushes to move the finger paint around. When Nelson indicated he was finished, I gave them a clean piece of paper to make a print of the artwork. This fascinated Nelson, who joyfully took it home 'for papa.'

The same activity was repeated over several weeks. Cars were introduced so that lines could be made in the finger paint; Nelson got his hands messy, the cars got messy too, and part of the fun was washing off the cars in a small bowl after the activity was over. Within a few weeks, Nelson and his mother were enjoying the mess, and mother said Nelson was now trying more textures even with food. She was worried because

*Figure 32: It's fun to paint with hands and feet.*

*Figure 32a: Tactile and messy art makng.i*

he still had difficulty walking around on rugs. Therefore, before we began a series of foot paintings I encouraged them to play in the sandbox. At times sand found its way onto the floor. Then we took the small brush to pick it up, which necessitated more touching. I suggested we try to move the sand around with our feet. We all took off our shoes and socks and touched the sand on the floor with our feet. Nelson laughed as it tickled. Then I introduced paper with some paint; at first we added a bit of sand to make it gritty, later he could tolerate the smoothness of the finger paint on his feet. After a few tries feet painting became a favorite art form. Nelson was having fun with his mother. Mother was allowing herself to have fun with the messy material. The relationship was changing from one of power on both sides to one of cooperation. The special weekly time he had with his mother was paying off, and the sibling rivalry diminished and became manageable. Mother announced that she had begun doing finger paint with both her children. Nelson was proud to show his sister how to play with the messy material with his fingers and toes.

## Example 15: Clay and the battlefield

Rodney's parents were quite worried about his aggressive acting-out impulsive behavior. He had problems adjusting to day care, to kindergarten and now in regular school. I had worked with this boy off and on since he was at day care. The parents were cooperative, a new sibling had been born and although Rodney was not aggressive in his home, he had difficulty in a group. His grades at school were average and at seven years old his parents had hoped that he would manage with his peers in a more cooperative way, as they had been threatened with his being expelled. We began mother–child dyad art therapy. It was quite open-ended, Rodney had good drawing skills, and brought in pictures of monsters and nightmares. All of his drawings were of creatures attacking him. When I asked him to draw a picture where the situation would be changed, he drew a picture of the monsters being transformed into good creatures through a special happy charm. He had not chosen an aggressive way of disarming his enemy. One day his mother chose the clay to work with. Rodney decided to build a fort, and using the little army of pewter soldiers and monsters, they began to set up good and bad

guy camps. At first his mother was resistant, as she did not allow her son to play pretend fighting, or with pretend guns, etc. I encouraged her to let Rodney act out with the clay and the toy soldiers and monsters. He gave her roles as the guard of the bad guys, or as the cook of the good guys. After each session Rodney would decide who was winning, and replace all the toys in the box and shape the clay into a ball. After several sessions of battles, the good guys seemed to be increasing as the bad guys (who went to his mother to be guarded by her) became good guys. In his play Rodney was showing us that bad guys could change if the guard who was a mother allowed it to happen. Little by little his impulsive behavior began to change, as the parents were able to focus on his good behavior. The dyad art therapy intervention was continued until the end of the school year. The parents reported that they made weekly time for Rodney and his mother to participate in special time together.

### Example 16: Tea, Cookies and plaster bandages

Although the focus of this book is on interventions with infants and preschoolers, in private practice I have often worked with pre-adolescents. Many methods must be at the disposal of the therapist in order to develop a working relationship with the dyad. The therapist must be as neutral as possible, facilitating the process, not imposing it. Marguerite was a 13-year-old girl, feeling torn between her parents who had been divorced many years earlier. It seemed that as she was reaching adolescence, the pain of the divorce and the constant stress and discord were affecting her. The mother had attempted several types of therapy with her, but she was unable to open up to anyone. She appeared to be keeping all her emotions bottled up. The mother said she was an artist and the daughter also. The materials in my studio are of a high quality, which should be appealing to artists. Nevertheless, the girl and her mother were in constant competition. They sat at opposite ends of the room, the girl kept criticizing her own work and negatively comparing it to her mother's art. There seemed to be very little that could be done to repair the relationship. Their resistance to interacting with each other as well as their resistance to engage in the art process caused me to feel very inadequate and helpless. The one saving factor was that they kept coming

and I wondered why. I had to ask myself where these feelings of inadequacy and helplessness were coming from.

On a cold January evening Marguerite and her mother arrived at their appointed time, cold and shivering as they had run out from the car without their coats. This was very unusual as the weather was very cold. They were both shivering, so I offered them a cup of tea to help them warm up, and some cookies to go with the tea. They became exited about the cookies, both explaining that it was their most favorite food and that they loved the mint tea. They chatted pleasantly with each other and for the first time in my office they seemed to be enjoying one another, like children at a pretend tea party. Tea and cookies became part of the therapeutic routine. Feeding the dyad appeared to be a necessary process. After the tea, they began planning a project together. They had expressed their emotional impoverishment in their inability to become engaged with the art materials and with one another. However, the actual feeding ritual seemed necessary to their therapeutic process.

Marguerite suggested to her mother that she should trace her body, an activity she had done when she was in kindergarten. Therefore, I produced a large piece of paper, Marguerite lay down on it and her mother traced her entire body. They both felt that they would like a stiffer ground, and asked for a large piece of cardboard or other material to solidify the form. It was as if another person had been introduced to the session. The only material I had in the studio was the plaster bandage (activity no.27) which they thought was great. So for the next two or three weeks, after the tea and cookies they became engaged in a reparation process, by covering the paper shape with plaster bandages. They carefully tended to the figure, rubbing the material gently, applying the warm bandages, as if they were treating and repairing a treasured doll. All this time, because of the size of the figure, they worked on the floor. When the figure was completely covered with the plaster bandages, they were able to stand it against the wall. Together they decided how the hair and eyes, should be colored and they named the figure 'Shirley.' They decided to make clothes for her. During the following week, the two went shopping for material and made Shirley a wardrobe. By springtime, the figure and clothes were completed and they told me that they no longer required the tea or the cookies. Mother and daughter shared the

meaning of this object, although they did not verbalize it. They continued coming to the sessions, used clay or paint and worked on joint projects. Mother reported in a separate interview that Marguerite's behavior at home had changed, and they were now planning and agreeing on her high school for next year. They brought Shirley home.

The therapist never knows how the dyad will begin to respond to one another. In this case, purely by accident I happened to have tea and cookies in my office. The tea party had been one of their fun times when Marguerite was a child. At around five years old, when she was attending kindergarten, the parents had divorced. Marguerite chose the activity of tracing around her body that had brought her pleasure. She spontaneously returned to an emotionally difficult time in her young life. Together they repaired the doll with the plaster bandages; it was as if Marguerite had been put in a body cast. The doll became the focus of the sessions, and the material of their conversations. The dyad's painful emotions were sublimated in the creation of this object. Without the mother in the sessions, I do not think that this hurt would have materialized and been repaired in this sublimated manner. Mother and daughter became like friends playing with paper dolls. Whether the doll represented the child or whether it represented the mother was never clarified. It would seem however, that she was invested with both of them and in this way the doll became the transitional object that allowed both members of the dyad to express and resolve their emotional needs together in the therapy.

I have found the parent–child-dyad art therapy intervention to be effective when working with the pre-adolescent, who may have issues around mother or father. Dyad art therapy then takes the onus of responsibility away from the young person and provides a forum where unresolved conflicts may come to the surface and be resolved. The stages of functional emotional development are observed during the course of treatment. Thus, the process of the therapy begins to unfold. This chapter has given you a glimpse into the workings of parent–child-dyad art therapy. A therapist may apply many activities to the model. The art therapy intervention may be integrated into a program that has behavioral, psychodynamic, and remedial components. All of these are essential ingredients of the art therapy intervention.

Through the anecdotal material shared with the therapist and the other parents in the group, we get some idea of the effects on the parent of doing art with their child. The parent–child-dyad work can be applied to individual dyads as well as to group work. The specific aim of this intervention is to include the parent as a direct participant in the child's treatment, permitting therapeutic input, and providing a window to monitor the parent–child relationship. The effect of the art expression on the parent has been secondary and unexpected. In the future, I hope to conduct more research focussing on this phenomenon, in order to prove scientifically the value of parent–child-dyad art therapy.

The list of suggested activities includes symbolic meanings and social development indications; these can be used to help the therapist until she creates her own interventions. These suggested activities are not to be followed numerically; they have been numbered only to help in their identification. As you have observed in some of the examples given, materials from one can be included spontaneously in other interventions. In this manner, new modes of treatment are created and can be added to our repertoire of interventions. I recommend that, before applying an intervention with the dyad, the art therapist take the time to articulate the process, the materials and the product outcome. However, the group of dyads, or the dyad itself may bring the therapist to spontaneously intervene. After the session, an analysis of the symbolic meaning of the material (why and how it was introduced to the session) may give some insight into the therapeutic process of the client. In this manner, she can identify the transference and counter transference, and begin to understand how it will affect the emotional and the social development of the child. In this way, she will get a deeper understanding of herself and of her work with the parent–child-dyad.

# Symbols and Metaphors in Art Making

The following interventions were applied to dyad art therapy with success. Some of them are adaptations of regular art therapy activities, others were created by the necessities of the group and still others were introduced to the process by the art therapy interns during their practicum in the department. I have labeled the interventions in this chapter as follows:

- Individual and group dyad art therapy intervention.
- Group cohesion and turn-taking intervention.
- Sculpture intervention.

All are suitable for directive or non-directive art therapy. I have indicated the activities which are also suitable for the infant age group (zero to three years). These are labeled infant, preschool and up. Activities suitable for infants may also be suitable for children with disabilities or developmental delays. This is simply a list; although the activities are numbered for ease of reference, they are not to be followed chronologically. I find it is important for the art therapist to be in tune with the needs of her group and the list of activities will give her a menu from which to choose the appropriate intervention. These activities have been included because of the many requests I have received to print them. I hope that they will spark the creativity of the practitioners or of the parents reading this book.

The intention of including these activities in this book has been to assist new therapists or parents who would like some help in how to create fun therapeutic activities with their children. It is hoped that these ideas will spark the creativity of the reader, and allow themselves to begin to think like a child, and have fun like a child. In this manner the intervention will be a success.

It is important to note that the activities all have symbolic meaning – usually one of attaching things together, with glue, self-adhesive paper or tape, or one of feeding, such as the use of flour, cornstarch or making pizza. The other symbolic aspect is one of a secure base, in attaching the work surface securely to the table in front of the dyad, or working in a contained, transitional space such as a box, box cover, or tray. The other important factor in these interventions is their presentation: the material should speak for itself. It should be presented in such a way that few verbal directions are needed. Even the children may say 'We are making play-dough today,' or 'We are drawing today.' The interventions listed below have all been used in the course of dyad art therapy in groups and with individuals. You will no doubt recognize some of these applications, as the art materials are broadly used by art therapists. However the application of the materials may differ in these interventions. The dyad interventions usually differ depending on the needs of the group or of the dyads. Therefore, the therapist should exercise flexibility when working with dyads. Furthermore, I do not take credit for all the activities that were invented during my clinical work; some have evolved, others were taken from my experience working with infants in play groups, and still others were introduced by interns during the course of their practicum. I refer to the age group, although the activities marked *infant* can be used with children, or adults with developmental delays. The directions have been formulated for groups of six dyads. Reduce the amounts as needed.

## Individual and group dyad art therapy intervention

*No. 1 Collage: Abstract art*

Age group: infants (as young as nine months), preschoolers and up

MATERIALS

- Self-adhesive (contact) paper (type for covering shelves)
- Cardboard or construction paper approx. 12" x 18" (28.9 x 41.1cm)
- Masking tape
- A pile of paper in a variety of shapes, textures, color, and sizes
- Shakers (salt or spice bottles) containing dry jelly powder, flour, spice
- Sparkles for the preschoolers and up
- 12 felt-tip markers

METHOD

Create the boundaries by securely taping the self-adhesive (contact)paper (sticky side up) on all sides, to the cardboard. Create holding environment by attaching, with tape, the four corners of the cardboard to the table (where both the parent and the child will sit). Attractively place the pile of paper in the middle of the table, enabling all to reach (reserve the shakers and the markers till later). When a child begins to fidget and the parent is having difficulty engaging him, introduce the shakers and demonstrate by shaking (for the infants the jelly powder replaces the sparkles). Give each dyad two shakers; encourage the mother to shake, and encourage the group to exchange the various types of shaking materials. When the child indicates that he is finished shaking, give the mother two markers, and ask that she write her name and her child's at the bottom of the cardboard. The child can scribble around and on the collage with his marker, thus keeping him engaged. Upon termination, the dyad carry the artwork together to the wall and the mother helps the child to push on the tape to hold it there.

DIRECTIVE

Remove the covering from the paper. Show with your finger how the surface is sticky. Say: 'Make a collage by choosing a piece of paper and putting in on the sticky surface, continue until all the surface is covered.'

SYMBOLIC MEANING

Within a boundary created for the child and the parent to interact, sticking objects to the surface becomes a concrete attachment symbol.

SOCIALIZATION AND DEVELOPMENT

The activity enables the *parent* to follow the child's lead or to encourage the child to place paper on the sticky surface, thus participating in an activity at the same developmental level as the child. The dyad becomes stimulated by the color and texture of the paper, and by the shaking of the material onto the collage. The *child* becomes able to tolerate the parent participating in his/her activity and learns about cause and effect.

## Individual and group dyad art therapy intervention
*No. 2 Collage: Shapes*
Age group: infants (24 months and over), preschoolers and up

MATERIALS

- 6 pieces of cardboard or construction paper approx. 12" x 18" (28.9 x 41.1cm)
- Masking tape
- 6 pieces of colored poster board cut into large shapes such as: circles, triangles, Christmas trees, with a hole punched through the top with a hole punch
- Pieces of multi-colored tissue paper, cut into one inch squares
- 6 Styrofoam™ trays
- White glue
- 6 shallow wide-mouthed containers (plastic lids are ideal)
- Food coloring
- Shakers
- Pipe cleaners
- Wet washcloths

DIRECTIVE

'For this activity you take a piece of paper, scrunch it, dip it into the colored glue, and place it on the shape.' (Demonstrate as you speak, on your own prepared ground.)

METHOD

Create the boundaries by securely attaching the cardboard on the table with the masking tape, in front of the position each dyad will take at the table. Attach the colored poster board shape in the center of the cardboard. Place the pieces of multi-colored 1" squares on a foam tray at the top and center of the cardboard. Next to it place a container of white glue which has been colored with a few drops of food coloring. For this activity, the therapist scrunches one piece of paper into a ball, dips it into the colored glue, and

places it on the colored shape. The mother mirrors her example and shows the child how. Both mother and child now proceed to fill the shape with the paper flowerets. It is important to have a wet washcloth handy, as the child's hands will get sticky. Now bring out the shakers, the contents of which will absorb the excess glue, while the shaking movement will allow the child to keep his focus on the activity. When they are done, have the parent remove the colored glued shape from the cardboard and get them to thread the pipe cleaner into the hole, then place on a flat surface to dry. Before leaving, the parent and the child can carry their shape home by the handle. If it's holiday time, it can be used as a pretty decoration which they have made together.

SYMBOLIC MEANING

The shape is attached to the cardboard which is firmly attached to the table, thus establishing a transitional attachment space. The glue is for sticking elements together, the food coloring for visual stimulation.

SOCIALIZATION AND DEVELOPMENT

The child is given the opportunity to control the messy situation which provides close, simple reciprocal cause and effect communication. He may get his hands sticky, and his mother may or may not enjoy, getting hers sticky too. They share the interaction, the clean up, and carrying home the object. The child's fine motor development may allow him to scrunch the paper, or he may allow mother to do so, thus he acquires cooperation and power by doing something with his parent.

## Individual and group dyad art therapy intervention
*No. 3 Collage: Motifs*
Age group: infants (24 months and over), preschoolers and up

MATERIALS

- 6 pieces of black cardboard or construction paper approx. 12" x 18" (28.9 x 41.1cm)
- Masking tape
- 6 pieces of colored poster board cut into large shapes such as a snowman or a bunny with long ears. Choose the same motif for the whole group
- Cotton balls
- 6 Styrofoam™ trays
- White glue
- 6 shallow wide-mouthed containers (plastic lids are ideal)
- Food coloring
- Shakers
- Felt-tip markers
- Wet washcloths

DIRECTIVE
'Lets make a snowman with these cotton balls dipped in the colored glue.' (Demonstrate as you speak on your own ground.)

METHOD
Create the boundaries by securely attaching the cardboard to the table with the masking tape, in front of the position each dyad will take at the table. Attach the snowman or bunny shape in the center of the black cardboard. Place some cotton balls on a Styrofoam™ tray at the top and center of the cardboard. Next to it place a container of white glue which has been colored with a few drops of food coloring. With the markers suggest that eyes, nose and mouth be colored on.

## SYMBOLIC MEANING

The soft cotton balls are symbolic of the first caring of the baby. The soft cotton balls are ticklish. The texture and the production are visually stimulating. The product is symbolic of representation in the environment.

## SOCIALIZATION AND DEVELOPMENT

The child is usually happy to create a snowman or a bunny. The representation is a fun one that they can all relate to. Requires some control to keep within the boundaries of the form. The black background creates a contrast and stimulates the non-attentive infant.

## Individual and group dyad art therapy intervention

*No. 4 Collage: Story telling*

Age group: preschoolers and up

MATERIALS

- 6 pieces of black cardboard or construction paper approx. 12" x 18" (28.9 x 41.1cm)
- Masking tape
- 12 glue sticks
- A variety of pictures cut out from magazines
- A variety of odd pieces of colored paper
- 6 small boxes of oil pastels

DIRECTIVE

'Each of you choose three pictures from the pile. With these six pictures create a collage and make up a story which you can elaborate and decorate with the colored paper or the oil pastels.'

METHOD

Create the boundaries by securely attaching the cardboard to the table with the masking tape, in front of the position each dyad will take at the table. Each dyad has two glue sticks and a box of oil pastels at the top of their working space. The pictures and colored paper are strewn in the middle of the table. After they have their aprons on and are seated, give the directive. To bring closure, ask the parents and the child to put their names on their product. Have the dyad hold up their picture and tell the group their story. If the child will not speak, or cannot speak, ask the parent to tell the story. If they cannot, ask 'What was your favorite color? What was John's favorite color, or picture?' etc. Only a few words are sufficient, thank the dyad and move on to the next, or you might lose the group if they have to wait too long for their turn.

## SYMBOLIC MEANING

The pictures will symbolize the mental representations. The paper and crayons are symbolic of the dyad's ability to elaborate a theme. The placement of the objects on the paper will represent cohesion or separateness of the dyad.

## SOCIALIZATION AND DEVELOPMENT

Are the parent and the child able to cooperate enough to create a story from six unrelated pictures? How are they able to use the other objects on the table? Can they create a story together, or each their separate story? Can they share with each other? Can they pretend, or are they giving concrete descriptions? Can they tell the group their story? This activity will give you ample information as to the status of the child's development and the dyad's relationship.

## Individual and group dyad art therapy intervention

*No. 5 Collage: The trip*

Age group: Preschoolers and up

MATERIALS

- 6 pieces of cardboard or construction paper approx. 12" x 18" (28.9 x 41.1cm)
- Masking tape
- White glue
- Glue brushes or applicators
- From magazines cut a variety of pictures of cars, trucks, airplanes, trains, boats, and pictures of environments, landscapes, air and clouds, water etc.
- Felt-tip markers
- Toy telephone

DIRECTIVE

'Plan a trip, for just the two of you, it can be to anywhere. Choose your transportation: a car, a truck, an airplane, a train, a boat, etc. Choose an environment, or draw one. Glue it to your paper, and draw a picture, like a map of where you start from and where you arrive.'

METHOD

Create the boundaries by securely attaching the cardboard to the table with the masking tape, in front of the position each dyad will take at the table. Each dyad should have two glue applicators, and a small quantity of glue in a shallow, wide-mouthed container (plastic lid is ideal). Each dyad should have four felt-tip markers, any color. At the end of the activity, ask the parents and the children to write their names on the artwork. Produce the toy telephone and suggest that the dyad call a favorite person to tell them about the trip they are taking. The group listens and waits their turn for the phone. Both may want a turn to talk, or the parent may talk for the child.

## SYMBOLIC MEANING

They are taking a trip together, a special time for the two of them, symbolic of the time in the womb. They are moving away from others and using their imaginations. The type of transportation, and the destination are also symbolic.

## SOCIALIZATION AND DEVELOPMENT

The parent and child are going somewhere together, but they socialize by calling someone and telling them of their plans. The dyad uses their imagination, cooperation, and communication skills.

## Individual and group dyad art therapy intervention
### *No. 6 Collage: Glue dripping*
Age group: preschool

MATERIALS

- 6 pieces of cardboard or construction paper approx. 12" x 18" (28.9 x 41.1cm)
- Masking tape
- White glue
- Food coloring
- 12 Popsicle® sticks
- Variety of small pieces of paper, texture, tissue, foil
- Sparkles to sprinkle
- Felt-tip markers

DIRECTIVE

'Today we are going to make a picture by letting the paint drip off the end of the Popsicle® sticks.' (Demonstrate on a separate paper.)

METHOD

Prepare the glue by adding food coloring to it. Each color of glue should be in its own small cup type container, clear if possible. Tape the cardboard or paper in front of each dyad. Place two Popsicle® sticks in each container of glue. Mixing two or more food colors can create a variety of colors. Demonstrate, on a separate paper, the process of allowing the colored glue to drip onto the paper and the lines and puddles that can be created. When there appears to be a sufficient amount of lines on the paper, being careful to prevent chaotic discharge, introduce pieces of paper to be placed on the surface, or introduce the sparkles to be shaken onto the surface. It may not be necessary to introduce both the paper and the sparkles at the same session. This decisions depends on the process of the art making. At times, the participants may ask to drip more colored glue over the top of the collage, and this produces again another effect.

SYMBOLIC MEANING

The process of dripping the colored glue and attaching a variety of materials to it may represent the family or group relationships.

SOCIALIZATION AND DEVELOPMENT

Helps the child to develop control over material. Develops observational skills as he watches his glue and his parent's glue dripping and forming different designs. This process assists the child in decision making with the placement of the paper on the dripped glue. The process promotes cooperation.

## Individual and group dyad art therapy intervention

*No. 7 Painting: Abstract art*

Age group: infants, preschoolers and up

MATERIALS

- 6 pieces of cardboard or construction paper approx. 12" x 18" (28.9 x 41.1cm)

- Masking tape

- 12 paint brushes (short handle 1" brushes). Have extra for the kids who want to paint with two hands

- Liquid tempera paint (3 primary colors plus 1, avoid black)

- 6 Styrofoam™ trays

- Wet washcloths, towels

- 6 felt-tip markers

DIRECTIVE

When the group is seated with their aprons on you can say, 'With the paint that is in front of you, together paint the paper.'

METHOD

Create the boundaries by securely attaching the cardboard to the table with the masking tape, in front of the position each dyad will take at the table. In front of each cardboard, or strong paper, place a Styrofoam™ tray with four medium blobs of paint. Place a paint brush on each side of the tray. If they are having trouble starting, suggest that they use their favorite color. If the child insists on using both paint brushes, provide another one for the parent. The colors will become all mixed together; observe how either the parent or the child react to this. If the child wants to put their fingers in the tray, use the washcloth, and direct the dyad to use the brushes. Some parents have a difficult time, applying limits. Some children test limits regularly. Therefore it is important as the therapist that you apply and maintain the limits with the art materials. Through your modeling both the parent and child will begin to understand the boundaries. At the end of the session give the parents the markers and ask them to write their name and the child's on the paper. When dry remove from the table and place on the wall.

SYMBOLIC MEANING

The parents are encouraged to follow the child's lead: to use the color the child used, to make the same marks as the child, and therefore create a very early cause and effect experience – 'I do this and mother does it too.'

SOCIALIZATION AND DEVELOPMENT

The child begins to experience sharing the paints and the paper area. He can mix all the paints without being admonished, and he can be validated by his mother or father painting in the same manner he paints. While painting, the use of small and large motor skills and mastering the brush makes the child aware of himself.

## Individual and group dyad art therapy intervention
## Group cohesion and turn-taking intervention
*No. 8 Painting: Lots of brushes*

Age group: infants, preschoolers and up

MATERIALS

- 6 pieces of cardboard or construction paper approx. 12" x 18" (28.9 x 41.1cm)
- Masking tape
- 12 sponge brushes (various widths)
- Tempera paint (6 colors)
- 6 Styrofoam™ trays
- Felt-tip markers

DIRECTIVE

When the dyads are seated, all wearing aprons, say, 'Paint a picture with the sponge brushes, and share the paint. When you are ready to change color, leave the brushes for that color in the paint tray.'

METHOD

Create the boundaries by securely attaching the cardboard to the table with the masking tape, in front of the position each dyad will take at the table. In the center of the table, place the six Styrofoam™ trays with six colors in them. In each tray place two sponge brushes of the same size. Therefore, each tray will have a different color of paint and different sizes of brushes. When the painting is complete, give the dyad a marker and have them write their names on the work. When dry place on the wall.

SYMBOLIC MEANING

The paper represents a secure space. Waiting and sharing symbolizes dynamics in a family.

SOCIALIZATION AND DEVELOPMENT

A new tactile experience for both the parent and the child which develops the ability to wait and to share the colors and brushes with the group as well as with their parent.

## Individual and group dyad art therapy intervention
## Group cohesion and turn-taking intervention
*No. 9 Painting: Plate painting*
Age group: infants, preschoolers and up

MATERIALS

- 6 pieces of cardboard or construction or heavy paper approx. 12" x 18" (28.9 x 41.1cm)
- Cover table with craft paper
- Masking tape
- 6 paper or aluminum or regular plates
- Liquid tempera paint (3 primary colors)
- 12 long-handled paint brushes.

DIRECTIVE

'Hold the plate close to the child so that he can reach the paint, and follow his lead in mark making.'

METHOD

a.  Create the boundaries by securely attaching the cardboard to the table with the masking tape, in front of the position each dyad will take at the table. Place the plate containing the paint on the cardboard, with the two paint brushes, one on each side of the plate. Have extra brushes handy if an infant wants to use both his hands.

b.  This activity may be used for group cohesion by covering the whole table top with craft paper.

SYMBOLIC MEANING

The plate is a womb-like round container which is held securely by the parent for the child to mix and swirl the paints. A feeding situation is re-created. The use of the long-handled paint brush promotes the beginning of separation and distance between parent and child.

SOCIALIZATION AND DEVELOPMENT

Fine and gross motor stimulation with brush control. Taking turns, and leading the interaction. In b) they create a mural together.

## Individual and group dyad art therapy intervention
*No. 10 Painting: Sponge painting*
Age group: preschoolers and up

MATERIALS

- 6 pieces of cardboard or construction paper approx. 12" x 18" (28.9 x 41.1cm)
- Masking tape
- 12 sponges (various shapes)
- Tempera paint (6 colors)
- 6 Styrofoam™ trays
- Felt-tip markers
- Wet face cloths

DIRECTIVE

When the dyads are seated, all wearing aprons, say, 'Use the sponges to print a picture, and share the paint and sponges. When you are ready to change color, leave the sponges for that color in the paint tray.'

METHOD

Create the boundaries by securely attaching the cardboard to the table with the masking tape, in front of the position each dyad will take at the table. In the center of the table, place the six Styrofoam™ trays with six colors in them. In each tray place two sponge shapes. Therefore, each tray will have a different color of paint and different sponges. When the painting is complete, give the dyad a marker and have them write their names on the work. When dry place on the wall.

SYMBOLIC MEANING

The paper represents a secure space. Waiting and sharing symbolizes dynamics in a family. The shapes represent object representations.

SOCIALIZATION AND DEVELOPMENT

A new tactile experience for both the parent and the child which develops the ability to wait and to share the colors and sponges with the group as well as with their parent. They get their hands dirty. They can repeat the object representation over and over again.

# Individual and group dyad art therapy intervention

*No. 11 Painting: Picture*

Age group: infants, preschoolers and up

MATERIALS

- 6 pieces of cardboard, construction, or strong paper approx. 12" x 18" (28.9 x 41.1cm)
- Masking tape
- 12 brushes
- 6 trays of tempera wafers
- 6 shallow, wide-mouthed containers for water

DIRECTIVE

1.   'Paint a picture of anything you like to do with your mom or dad.'

2.   'Paint a picture with a house, a tree and a person in it.'

METHOD

Create the boundaries by securely attaching the cardboard to the table with the masking tape, in front of the position each dyad will take at the table. Above the cardboard, place the tray of tempera wafers, which you wet. Next to the tray place the container for water. On the cardboard place the two paint brushes. When the dyad have completed, remind them to write their name or initials on the paper. Have each dyad in turn hold up their painting and tell the group the story they have painted. Have the children and the mothers affix the painting to the wall.

SYMBOLIC MEANING

The taped paper creates a transitional space where the parent and child can communicate non-verbally. The painting becomes the transitional object.

SOCIALIZATION AND DEVELOPMENT

The child has the ability to represent a situation. He can now tell the story to the group, even with a little help from the parent.

## Individual and group dyad art therapy intervention
## Group cohesion and turn-taking intervention

### No. 12 Painting: Car painting

Age group: infants, preschoolers and up

MATERIALS

- 6 pieces of cardboard or construction or heavy paper approx.
  12" x 18" (28.9 x 41.1cm)
- Masking tape
- 12 small plastic cars with wide wheels and some molded plastic
  type people fitting in the cars (ambulances, tractors, etc. are fun)
- Liquid poster paint
- Wet face cloths
- Felt-tip markers

DIRECTIVE

After the dyad are seated and wearing their aprons you can ask them to,
'Drive your cars through the puddles of paint, make marks with the wheels,
and then let the little people walk though it. Make up a story.'

METHOD

Create the boundaries by securely attaching the cardboard to the table with
the masking tape, in front of the position each dyad will take at the table. On
each cardboard, place two cars and put several drops of paint about the size
of a quarter, to create the puddles. When the dyad have covered the paper
with the paint, have them write their names on the artwork and ask each
dyad to tell their story to the group.

SYMBOLIC MEANING

In the transitional space, the children can practice moving away from their
parent, they might have accidents, and fall in the mud. A safe place to
practice cause and affect experiences.

SOCIALIZATION AND DEVELOPMENT

Some children may have delays in fine motor development; this intervention
provides them with the opportunity to follow everyone else.

## Individual and group dyad art therapy intervention
*No. 13 Painting: Finger painting and mono prints*
Age group: infants, preschoolers and up

MATERIALS

- 6 pieces of cardboard,heavy paper, or newsprint approx. 12" x 18" (28.9 x 41.1cm)
- Masking tape
- Finger paints
- Aluminum foil
- Felt-tip marker
- Wet face cloths
- Use plain yogurt and food coloring for under 24 months.

DIRECTIVE
'Now you can paint with your fingers and with your hands, we will make a print of it.'

METHOD
First cover the cardboard with aluminum foil. Then, create the boundaries by securely attaching the cardboard to the table with the masking tape, in front of the position each dyad will take at the table. At the top of the aluminum-covered cardboard, place four teaspoons of different colored finger paint. Have the newsprint ready to use, and a felt marker to write the child's name on the artwork. Repeat the prints a few times.

SYMBOLIC MEANING
The aluminum foil acts as a reflecting sheet. The smooth finger paint is symbolic of the smooth cream that mother rubs on the infant. It is also symbolic of messy incidents. The repetitiveness of the printmaking symbolizes the ritualistic repetitiveness of parenting. The prints are hung on the wall, and the dyads can talk about how they felt when they made them.

SOCIALIZATION AND DEVELOPMENT
The sense of touch is stimulated. The children learn that they can make beautiful prints from the messy paint. Parent and child participate in the fingerpainting, touch hands and feel closeness.

## Individual and group dyad art therapy intervention

*No. 14 Painting: Food coloring treasure map*

Age group: preschoolers and up

MATERIALS

- 6 pieces of cardboard or construction paper approx. 12" x 18" (28.9 x 41.1cm)
- Masking tape
- Long narrow paper approx. 3" x 24"
- 6 Styrofoam™ trays or saucers
- Cotton tipped sticks (Qtips™)
- Food coloring

DIRECTIVE

'With the special stick and the food coloring you can create a secret treasure map, that we can roll up small to hide when we are finished.'

METHOD

Create the boundaries by securely attaching the cardboard to the table with the masking tape, in front of the position each dyad will take at the table. Place the long narrow paper on the cardboard. Each dyad has a Styrofoam™ tray on which you have placed some drops of food coloring, and six cotton tipped sticks for each participant. When the dyad are finished their map, they have the choice to keep it a secret or to share it with the group. They can then hide it.

SYMBOLIC MEANING

The treasure map is something to follow to reach happiness. The child makes the secret treasure with their parent and can feel secure that no one else will find it by hiding it. They are cohorts with their parent, they share the meaning of the artwork.

SOCIALIZATION AND DEVELOPMENT

Practicing fine motor skills. They are using their imagination and memory. They can now share a special moment with their parent.

## Individual and group dyad art therapy intervention
*No. 15 Drawing: Felt-tip markers*
Age group: preschoolers and up

MATERIALS

- 6 poster boards or drawing paper approx. 12" x 18" (28.9 x 41.1cm)
- Masking tape
- 6 boxes of felt-tip markers or 6 Styrofoam™ trays with a variety of markers

DIRECTIVE

'Draw something that you like to do with your mom or dad.'

METHOD

Create the boundaries by securely attaching the drawing paper to the table with the masking tape, in front of the position each dyad will take at the table. Place a box of felt-tip markers in front of each dyad. When they are finished ask them to write their names on the paper. Have them tell their story to the group and then affix the drawing to the wall.

SYMBOLIC MEANING

The boundaries provide a safe place to share this special moment. It brings back good memories and strengthens relationships.

SOCIALIZATION AND DEVELOPMENT

They share with the group. They use their memory and their imagination, as well as their fine motor skills.

## Individual and group dyad art therapy intervention

*No. 16 Drawing: Water soluble crayons*

Age group: infants, preschoolers and up

MATERIALS

- 6 pieces of cardboard or fingerpaint construction paper approx. 12" x 18" (28.9 x 41.1cm)
- Masking tape
- 6 boxes of 6 or 8 water soluble crayons or 6 Styrofoam™ trays with a few crayons on each
- 6 shallow wide-mouthed containers (plastic lids) for water

DIRECTIVE

'Make a picture of anything you like.'

METHOD

Create the boundaries by securely attaching the cardboard or paper to the table with the masking tape, in front of the position each dyad will take at the table. On a separate piece of paper, demonstrate by taking a crayon, dipping it in the water and making a mark on the paper.

SYMBOLIC MEANING

Water symbolizes the beginning of life. The paper becomes a secure base from which to develop a relationship.

SOCIALIZATION AND DEVELOPMENT

The cause and effect experience of water and crayon develops fine motor skills and cooperation.

## Individual and group dyad art therapy intervention
## Group cohesion and turn-taking intervention
*No. 17 Drawing: Water soluble crayons and bubble blowing*
Age group: preschoolers and up

MATERIALS

- 6 pieces of cardboard or fingerpaint construction paper approx. 12" x 18" (28.9 x 41.1cm)
- Masking tape
- 6 boxes of 6 or 8 water soluble crayons or 6 Styrofoam™ trays with a few crayons on each
- 6 shallow wide-mouthed containers(plastic lids) for water
- 1 bottle of bubble blowing material, with the wand

DIRECTIVE

'We are going to take turns blowing bubbles and letting them fall onto the paper in front of us. Then with the crayons we will draw our wishes into the bubble print.'

METHOD

In a turn-taking manner, each dyad will blow some bubbles onto the table and onto their paper, where they will burst. Then the dyads decide what they would want to wish for and they draw the wish into the wet shape left by the bubble. When the activity is over, the therapist asks them to tell the group their wishes.

SYMBOLIC MEANING

The bubbles represent the unconscious, the unknown, the mystery. The wishes represent reality.

SOCIALIZATION AND DEVELOPMENT

It develops pleasure in a group as the children find enjoyment in watching the bubbles that the others are blowing. A turn-taking activity promotes cooperation and attention. Drawing the wishes permits the abstract concept to materialize on the paper. Talking about the drawing helps in verbal skills and in processing the experience.

## Individual and group dyad art therapy intervention
*No. 18 Drawing: Chalk*
Age group: infants, preschoolers and up

MATERIALS

- 6 pieces of cardboard, heavy or construction paper approx. 12" x 18" (28.9 x 41.1cm)
- Masking tape
- 6 pieces of sandpaper 8" x 12"
- Several pieces of colored chalk: fat sidewalk chalk and blackboard chalk in bright colors
- Wet sponge

DIRECTIVE
'Draw a picture, by covering the sandpaper.'

METHOD
Create the boundaries by securely attaching the cardboard to the table with the masking tape, in front of the position each dyad will take at the table. Tape the sandpaper on all sides securely to the cardboard, which is taped to the table. After the group is seated, with the wet sponge, generously wet the sandpaper. Demonstrate on your own paper how to rub the chalk on the rough wet surface, on the masking tape frame and on the attached cardboard. At the end of the session have the dyad write their name on the cardboard, and have the participants share with the group what this experience felt like.

SYMBOLIC MEANING
A secure base and safe area where an unusual tactile experience allows them to gain perception and control in the manipulation and cooperation of the media. And paper is rough, masking tape is slippery and the cardboard is smooth, symbolising the perception of the parent–child interactions.

SOCIALIZATION AND DEVELOPMENT

Children will develop self-expression as they experience chalk in a variety of ways. Sharing colors and sizes of chalk with the group and with their parent develops cooperation.

## Individual and group dyad art therapy intervention

*No. 19 Drawing: Chalk on black construction paper*

Age group: preschoolers and up

MATERIALS

- 6 pieces of black construction paper. approx. 12" x 18" (28.9 x 41.1cm)

- Masking tape

- 6 small boxes of white chalk or pieces of chalk on a Styrofoam™ tray

DIRECTIVE

'Draw a picture of having fun in the snow.'

METHOD

Create the boundaries by securely attaching the cardboard to the table with the masking tape, in front of the position each dyad will take at the table. Place the chalk in front of each dyad. Demonstrate on your own paper. When they have completed have them write their name on the paper, and in turn share their story with the group.

SYMBOLIC MEANING

Working with the dark and white colors creates contrast, which is considered to be the infant's first perceptions.

SOCIALIZATION AND DEVELOPMENT

Imagination exercises may be needed for some children and their parents in recalling fun and pleasant memories.

## Individual and group dyad art therapy intervention
### No. 20 Drawing: Bingo dabbers
Age group: infants, preschoolers and up

MATERIALS

- 6 pieces of construction paper or finger painting paper approx. 12" x 18" (28.9 x 41.1cm)

- Masking tape

- Several colors of dabbers (commercial type for dot art or non-toxic Bingo type dabbers are suitable)

DIRECTIVE

'Create a picture by pounding with the dabbers on the paper.'

METHOD

1.  Create the boundaries by securely attaching the construction paper to the table with the masking tape, in front of the position each dyad will take at the table.

2.  Create the boundaries by securely attaching the finger painting paper to the table with the masking tape, in front of the position each dyad will take at the table.

The dabbers are place in the center of the table, with some within easy reach of the children. Demonstrate on your own paper, how the dabbers are pounded onto the paper.

1.  The construction paper absorbs the liquid color.

2.  With the smooth surface on the finger painting paper, the dabbers also run smoothly on the paper.

This activity causes splashing; ensure that the participants wear aprons. At the end of the session, ask them to write their name on the paper, and have the group share their feelings about the experience.

SYMBOLIC MEANING

The small bottles, easily held by the child, symbolize the feeding bottle, or the breast. The pounding symbolizes non-verbal aggressive feelings.

SOCIALIZATION AND DEVELOPMENT

A socially acceptable way of expressing aggression.

## Individual and group dyad art therapy intervention
*No. 21 Drawing: Modeling clay*
Age group: preschoolers and up

MATERIALS

- 6 pieces of cardboard or construction paper approx. 12" x 18" (28.9 x 41.1cm)
- Masking tape
- Variety of colored modeling clay cut into miniature pieces
- Styrofoam™ trays containing separate colors
- Felt-tip markers

DIRECTIVE
'Make a story picture with the modeling clay.'

METHOD
Create the boundaries by securely attaching the cardboard to the table with the masking tape, in front of the position each dyad will take at the table. Demonstrate how the modeling clay will adhere to the cardboard by firmly pushing on it; how colors may be combined, or if the children's fine motor skills are weak, how the modeling clay can be rolled into a snake form and after it has been warmed by the manipulation, it will firmly attach to the paper. When they have completed the intervention, have them write their names on the edge and ask them to share their story.

SYMBOLIC MEANING
In the secure base of the dyad exploration, the child and parent attach small pieces together to make an art object.

SOCIALIZATION AND DEVELOPMENT
Visual and fine motor stimulation as well as using memory and/or imagination. Cooperation and communication with the parent and with the group are needed.

### Individual and group dyad art therapy intervention
### Group cohesion and turn-taking intervention
### Sculpture intervention

*No. 22 Play-dough making*

Age group: infants, preschoolers and up

MATERIALS

- Flour in a wide-mouthed container
- 1 cup scoop
- Salt in a wide-mouthed container
- ½ cup scoop
- Large wide-mouthed mixing bowl
- 13 wooden long-handled mixing spoons
- Food coloring
- 1 cup measure for water
- 6 child size pastry rollers
- Cookie cutters
- Popscicle® sticks for pretend knives

DIRECTIVE

'Today we are going to make play-dough with this flour and the salt.'

METHOD

In a turn-taking manner, the child and the parent will put two scoops of flour into the bowl. It is often difficult for the child to take turns with his parent. Next, the turn-taking moves to adding two small scoops of salt. You get all the children to put their hands into the bowl in order to mix the flour and the salt. If the table is too large for the little ones to reach, pass the bowl around and have both the parent and the child mix the material together. Then you ask the group to choose a color, if more than one color is chosen create a mixture. You get the child to squeeze the food coloring into the measuring cup of water. Then you ask the children, 'Who can pour a little bit of water?' and you ask the parent to hold onto the cup of colored water, when you know that certain impulsive children will dump it all in. Then you give the

group each a wooden spoon, and again going around, you ask the dyad to stir the mixture. The mixture is then dumped onto the flour-covered table, to be kneaded. The therapist demonstrates, and then passes the dough around to be kneaded. The therapist checks to see that the dough is kneaded enough to not be sticky, she then divides the dough into six pieces and gives each child a piece with a stick, to act as a knife, and asks the child to share with their parent.

The group then proceeds to use the cookie cutters, or pastry roller, or to make other objects with the play-dough. At the end of 20 minutes, the therapist asks the dyads to tell the group about what they have made, and then to make a ball with the dough and place it into the container in the middle of the table. With the preschool group, this container is then placed in the kitchen corner, for the children to use during free play. With the infant group, the play dough is placed into zip lock bags, that are identified with the child's name, and they bring the dough home with them. This play-dough keeps approximately one month in a sealed container, in the refrigerator.

## SYMBOLIC CONTENT

Making dough together is symbolic of community feeding. The flour and the salt are symbols of life and permanence. The water is symbolic of the 'Great Mother' and associated with birth (Cooper 1978). The activity becomes symbolic of community feeding. It is a non-threatening experience that brings out memories from the parents' childhood. Symbolically many non-verbal experiences are expressed at many levels.

## SOCIABILITY AND DEVELOPMENT

Turn-taking and cooperation. With many children with developmental delays, taking turns, sharing with their peers has become very difficult. We begin by introducing turn-taking with their parent. Not by imposing, but by asking the parent to contribute to the bowl in the same manner we ask the other dyads to do so. By observing the process, the child gets the idea, and copies his peers. This activity is repeated several times during the therapeutic months. Each time the children are able to share and cooperate more easily.

## Individual and group dyad art therapy intervention
## Group cohesion and turn-taking intervention
## Sculpture intervention

*No. 23 Clothes making and suitcases*

Age group: preschoolers and up

MATERIALS

- Large craft type strong paper, firmly secured to the floor, approx. 3' by 6' or more if the children in the group are older and larger

- 6 different colors of tempera paint

- A variety of types of painting tools. At least 6 different methods of painting: 2 rollers, and 1 tray of 1 color of paint; 2 large house type painting brushes and 1 tray of a different color; 2 wide sponge type brushes and 1 tray of another color; 2 long-handled artist type paint brushes with a different color of paint; 2 long barbecue type basting brushes with a tray of paint; 2 of 1 of the above, or something else that you can provide (the 6 trays of paint with the variety of types of tools are placed around the paper, well spaced)

- Variety of sponge shapes

- 6 felt-tip markers

- 12 pairs of scissors

- Glue

- Masking and scotch tape

- Decorating materials: buttons, lace, etc. (ask the parents to bring these from home), sparkles and pipe cleaners, etc.

- 12 pieces of poster board approx. 18" x 20" to make 6 suitcases

- 12 long pieces of pipe cleaner

- 72 clothes pins

DIRECTIVE

'This is a clothes-making activity and it will take four weeks to complete. In addition, when all the clothes are made we will hang them on the clothes lines.'

METHOD

1st week. You prepare the large paper on the floor, by taping it down securely, and you place the containers of paint and the various brushes around the paper, so that the dyads have room to move from one container of paint to the other. In this way they will be able to experience both the paint and the different brushes. When the whole of the paper is covered you replace the brushes with the sponges, and they can make sponge prints on the paper material. When they are done, and their hands are washed, you get them to stand around the painted paper and talk about what they did. The paper is placed in a safe place to dry. You tell the dyads that in the following session, the children will trace a piece of clothing around their parent, and the parent will trace clothing around the child. A shirt, or pants, or gloves, or a hat, or socks, etc. Now they are prepared for the next step.

2nd week. You place the dry paper material on the floor and you remind the children and the parents that they will trace a piece of clothing. You give them each a marker, you divide the paper, so they know where to trace, and you assist them in beginning. You ask them to write their name and their child's name on the articles of clothing. You give them the scissors, so they can cut out the block of paper that they have been working on. They can begin to cut out the pieces of clothing.

3rd week. They continue to cut out the clothing and begin to decorate it.

4th week. They complete decorating the clothing, and begin decorating the clothes pins.

5th week. They bring the clothes to the clothes lines (strung across the room) and the children hand the clothes to the parents who pin them up. The group looks at the clothing and point out what belongs to them, to their parent.

The suitcase. You begin making the suitcases (this can happen several weeks later) by showing the group a model. The two pieces of poster board are joined by masking tape, this we call a hinge. The pipe cleaner forms the handle. With the markers the children and the parent write their name and draw a picture on the outside of the suitcase.

Lastly, the clothes are removed from the lines, and the clothes pins act as the locks on the suitcase. The children proudly carry their packed suitcases out of the room.

SYMBOLIC CONTENT

Here we are working on the process of individuation. Tracing around them, and then being traced around increases the child's awareness of separateness: 'This is you and this is me.' Together they work at cutting these objects out of the paper, and together they attach objects to the paper clothing to decorate them. The child then gives the clothing to the parent who attaches it to the clothes line, often reminding the parent of seeing their own parent do this. Together they make a suitcase to carry the pieces of clothing of both the parent and the child, who carries the suitcase out: a metaphor for separation.

SOCIABILITY AND DEVELOPMENT

This activity makes the child aware of his own size and of his parent's size (they often comment on this). It is also a group activity where they share decorating the objects, and the clothes lines. It is a time for cooperation: from painting to cutting out to decorating, to hanging out and bringing in the clothes, and in making a suitcase. It helps the child to recognize and to memorize what he is doing.

## Individual and group dyad art therapy intervention
## Group cohesion and turn-taking intervention
## Sculpture intervention
### No. 24 Boxes
Age group: preschoolers and up

MATERIAL

- Wide variety of small boxes and tubes (ask the parents to start collecting them about 2 weeks before the project)
- Masking tape
- Plaster bandage or paper-mâché
- Tempera paint
- Brushes
- Markers

DIRECTIVE

With the boxes and the tape we will create a sculpture. I want each dyad to go to the table with the boxes and each choose two boxes that they will tape all together. Then you can return to the table and get one box each to add to your sculpture. Your sculpture can be abstract, or you can decide to make something.'

METHOD

1st session. Begin by giving the directive to the dyads when they are sitting in a group. Set up small working areas around the room so that the dyad can leave the group to go and work on their own. Have a roll of masking tape on each table. Give support to the dyad who may have had difficulty understanding the directive.

2nd session. Give them the opportunity to complete the attachment of the objects, and begin applying the plaster bandages. Each dyad will have a roll of plaster bandage and two pairs of scissors. If the child has difficulty cutting, ask the parent to hold the material stiff, so that the child can cut it. If the child's fine motor development is delayed, ask the parent to get the child to hold the material while he watches the parent cut. In this way both are involved in the process. Then give them a shallow container of warm water, and demonstrate how to wet the plaster and then apply it to the sculpture.

3rd session. Complete the plastering

4th session. Begin painting.

5th session. The sculpture can be decorated with paper, or sparkles, or they can draw doors and windows, ghosts, etc.

6th session. They give a name to the sculpture. They write the name on a paper and they display it on their workspace. The group gathers around each sculpture and the dyad tells the story about the sculpture.

### SYMBOLIC CONTENT

The box symbolizes the containing, an enclosure; it is an object (Cooper p.24). The boxes are attached together with tape in a symbolic attaching and holding metaphor. The plaster bandage is used to repair breaks. The sculpture becomes a symbol of the relationship.

### SOCIABILITY AND DEVELOPMENT

The child learns how to make choices and to cooperate in taping the boxes together with his parent, choosing how to place them. Also, deciding what the sculpture will represent, choosing paint and decorations and choosing a name for it, thus they are creating from abstract to concrete.

## Individual and group dyad art therapy intervention
## Sculpture intervention

*No. 25 Aquarium*

Age group: preschoolers and up

MATERIAL

- 6 containers 2" deep (the type of box that holds canned pop)
- Tempera paint: white and blue
- Brushes and small rollers
- Colored paper
- Felt-tip markers
- 12 pairs of scissors
- Sand
- Sea shells or macaroni sea shells for painting
- White glue (a small container of glue for each dyad)
- Thin clear acetate blue or green paper
- Clear tape

DIRECTIVE

'Today we are going to start a project that will take four or five times of coming to complete. Do you know what an aquarium is? We are going to make a pretend aquarium. We will begin by painting the box to look like water; first with the white paint then with some blue.'

METHOD

1ˢᵗ week. With blue and white paint and rollers the dyad paints the box top and bottom. Lay the box on a piece of newsprint and write the child's name on it.

2ⁿᵈ week. With macaroni shells, paint the sea shells. To these a few real sea shells may be added.

3ʳᵈ week. With a stick or small brush the dyads liberally apply the glue to the narrow side of the aquarium (see Figure 28a). Into the glue place the sea shells, and on top of the sea shells and the glue a good quantity of sand. I usually put the sand in small containers that allow it to pour out easily.

4$^{th}$ week. The dyad begins to draw and cut out the sea weed and the fish or mermaids and the castles, ships, treasure, etc. If the group members have delays in fine motor skills, some pre-cut shapes are supplied and the parents are encouraged to help the child draw eyes and mouths on these shapes (see Figure 28b).

5$^{th}$ week. The seaweed, etc. that they have prepared is glued to the back of the box. The fish are glued to small pieces of cardboard in order to make them look like they are swimming.

6$^{th}$ week. The boxes are covered over with a clear blue or green acetate plastic to give the impression of looking into a watery aquarium (see Figure 28c). In turn, the dyads show their completed aquarium to the group and tell a story of what is happening in their aquarium.

SYMBOLIC MEANING

The box represents the container that the dyad will work in. The sand and shells represent the beach, or fun in the water. The water and fish represent the unconscious. The elements at the bottom of the aquarium could be seen as unresolved conflicts: treasure, sunken ships, skulls, etc.

SOCIABILITY AND DEVELOPMENT

The child is learning to follow the directions given by the therapist and to look to the parent to see how to complete them. It allows them to take an abstract concept and make it real.

## Individual and group dyad art therapy intervention
## Sculpture intervention

*No. 26 Flower garden*

Age group: infants, preschoolers and up

MATERIAL

- Various colored tissue paper cut into 2" squares
- White, water soluble glue
- Food coloring
- Styrofoam™ trays for the glue
- Green powder paint in shakers
- 6 containers 2" deep (the type of box that holds canned pop)

DIRECTIVE

'We are going to make a flower garden.'

METHOD

Demonstrate how the pieces of paper can easily be scrunched up to resemble flowers. They are then dipped into the colored glue and placed on the bottom of the box. The dyad continues this process until the bottom of the box and the sides (if the dyad wishes it) are covered with tissue paper flowers. The therapist then introduces the shakers of green paint, which are sprinkled onto the flowers and the glue, creating the greenery.

SYMBOLIC MEANING

The box is the container, the flowers are life, the glue becomes the earth and the paint the greenery. The flowers are attached to the container, which symbolizes the attachment and holding qualities of the parent.

SOCIALIZATION AND DEVELOPMENT

Fine motor skills are used to scrunch the paper and dip it into the glue. If the child's motor skills are not sufficiently developed, the parent can scrunch the paper and the child can dip it into the glue and attach it to the inside bottom of the box. It is a turn-taking activity that develops cooperation. The child will find pleasure in shaking the green paint over the flower garden, and enjoy the product that they have created together.

## Individual and group dyad art therapy intervention
## Scupture intervention
*No. 27 Clay*

Age group: preschoolers and up

MATERIAL

- Clay
- Paper or cardboard
- Masking tape
- Markers

DIRECTIVE

'Today we are going to work with clay.' a) 'You can make anything you like with the clay.' b) 'With the clay I want you to build a nest together, and put anything you want in it.' c) 'With the clay I want you to create a family of animals.'

METHOD

Tape the paper or cardboard firmly to the table in front of the dyad. Place two balls of clay on the paper. If it is their first session using clay, you can demonstrate the pinching, punching, rolling methods with a separate piece of clay.

SYMBOLIC CONTENT

The clay symbolizes the earth and inexhaustible creativity; it is a material that encourages looking inward. For the child the clay is a muddy material that he can pinch, punch, and tear. He can create worms, serpents, etc. It is the first material used by primitive tribes to create containers.

SOCIABILITY AND DEVELOPMENT

The material allows the child to express aggressive feelings in a socially acceptable way. They are able to create something out of nothing. Working with clay also develops fine motor skills.

## Individual and group dyad art therapy intervention
## Group cohesion and turn-taking intervention

*No. 28 Goop*

Age group: preschoolers and up

MATERIAL

- 6 cups of cornstarch
- Large bowl
- 8oz measuring cup for water
- Food coloring
- Powder paint (tempera) in shakable containers
- Several sheets of newsprint to make mono prints

DIRECTIVE

'Today we are going to make goop!'

METHOD

Taking turns around the table, the dyads put scoops of the cornstarch in a wide-mouthed mixing bowl. You can suggest that they squeeze the cornstarch and listen to it 'squeak.' You can talk about the cornstarch being like baby powder. The parent begins to reminisce. The group adds water a little at a time. Together the group reaches into the bowl to mix the cornstarch and water with their hands, or you pass the bowl around the table to facilitate the mixing. You get the participants to test the goop by quickly hitting it with the tips of their fingers: when it bounces, and your fingers sink in when it stops bouncing, the goop is ready. They can play with the goop in the bowl, but they will enjoy it if you dump the goop on the table.

1. Get the group to slap the goop without splashing it.
2. Ask the group to try to push the goop into a pile.
3. Get them to drop the goop and watch it fall slowly.
4. Get them to make a fountain by filling their parent's hand.
5. Bury the parent's hand.
6. Make a ball and open your palm to watch it melt.
7. Break a ball open to see what is inside.

8.   Introduce powder paint, and have them rub it on the surface.

9.   Introduce markers, and have them draw, controlling the pressure.

10.   Introduce food coloring.

11.   Pull out print.

12.   Get them to pick up the goop and return it to the bowl.

SYMBOLIC MEANING

Goop is a paradox: it is wet and dry, it is hard yet soft. It symbolizes unknown elements. It is symbolic of feeding, of cleaning. It is soft and gentle like powder.

SOCIABILITY AND DEVELOPMENT

This material is an equalizer. The parents cannot master it thus the child and parent are at the same level of functioning. It is a turn-taking activity. It strengthens fine motor skills. It causes smiles, laughter and genuine enjoyment.

## Individual and group dyad art therapy intervention
## Group cohesion and turn-taking intervention
*No. 29 Painting: Pizza party*

Age group: Preschoolers and up

MATERIALS

- Large thick paper that will cover a round table or a large round piece of paper

- Paint and paint trays

- Brushes and rollers

- Long ruler and scissors

- Pizza toppings: a variety of pasta noodles, construction paper to represent sausage, olives, pimentos, etc.

- Shakers of orange and yellow powder paint to represent the cheese

- One or two pairs of long scissors or an exacto knife

DIRECTIVE

'We are going to have a pizza party. It will take four times of coming before we have finished making the pizza.'

METHOD

1$^{st}$ week. Together the whole group paints the large round piece of paper.

Choose a room or place in the room where the painting can be removed to dry.

Pretend we are putting it in the oven to cook.

2$^{nd}$ week. With the large ruler and a chalk, each dyad marks off their pizza point.

This can be cut out with an exacto knife or with scissors by the therapist.

The dyads go to different tables placed around the room with their pizza slice. On each table there will be a small container of white glue, two spreading sticks and a tray to collect some pizza topping. These have been previously laid out on a side table. They begin to glue some toppings.

3$^{rd}$ week. The dyads go to their individual tables and complete gluing the pizza topping.

Then they bring the pizza slices to the main table, to reassemble the pizza.

They shake the yellow and orange powder paint over it to cover it with cheese and pretend to put the pizza back into the oven to cook it.

4th week. The pizza is on the table when the group returns. The therapist will have written the dyad's name on the back of each point. They sit around the pizza, talk about how they made it, and about their favorite pizza, etc. They pretend to eat the pizza and then they place it into their folder for safekeeping.

## SYMBOLIC MEANING

This is a feeding intervention. The session begins with the preparation of the pizza, the toppings, the cheeses and eating it. Incorporation as the attached objects create the group meal.

## SOCIABILITY AND DEVELOPMENT

This group activity begins and ends in turn-taking. The dyads then separate from the group to communicate with each other and prepare their own feast. The group then returns to share and have a party together.

# Individual and group dyad art therapy intervention
# Group cohesion and turn-taking intervention
## No. 30 Sand play
Age group: infants and preschoolers

MATERIAL:

- Container of sand
- Buckets or cups for water
- Small animals and toys of all sorts
- Shovels
- Small broom or brush and dust pan

DIRECTIVE

'We have a sandbox to play in.'

METHOD

Place the sandbox in a readily available place. It usually becomes a part of free play. The child usually goes to it spontaneously.

SYMBOLIC MEANING

Getting down to earth.

SOCIABILITY AND DEVELOPMENT

It encourages both parallel and cooperative play with peers. It is rough and tactile. The child can play many games, build, bury, or destroy.

CHAPTER 6

# The Role of the Art Therapist
# as a Facilitator and Interpreter

In the parent–child-dyad art therapy activity, the therapist focusses on the relationship between the parent and the child. She is not the parent's therapist, nor the child's therapist, but the dyad's therapist. This is her focus. If she is unable to keep this focus, control of the group of six parents and six children cannot be maintained. The focus on the relationship is also the basis of the individual dyad sessions. In describing the therapeutic communication, Robbins (1986) reminds us of the ideas of Ernest Kris (1952) indicating that in viewing art as a communication there is a sender, a message, and a receiver: 'In the therapeutic communication, patient and therapist continually exchange their roles of sender and receiver, while the message that emerges is the product of their interaction. Therapy, then, can be an artistic expression of the two parties involved, and can be an invitation to a shared communication in which two minds intertwine on the deepest level of psychic existence' (p.19). In parent–child-dyad art therapy, the art therapist can witness the above phenomenon between the parent and the child, and she then becomes a third party in the shared communication. However, as Robbins tells us: 'In order to arrive at this profound level of communication, the therapist must employ an enlarged capacity to respond to non-verbal cues. This capacity on the part of the therapist may originate in his early relationship with his mother.' Robbins refers to Rene Spitz (1965) who offers us valuable information on the quality of this early sensory-motor dyad. He describes perception in this relationship as 'multimodalitied' although primarily visual: 'The mother–infant relationship then, is

experienced primarily as one of looking and being looked at, often accompanied by touching and cooing' (p.19).

The therapist, who has an in-depth knowledge of developmental milestones and capabilities of children, articulates the art activity and intervention so that all the children and parents in the group have a successful experience of touching, of looking and of being looked at. The art materials and activities must, therefore, be at a simple level so that the child who has the most difficulty can participate without feeling left out. The children who have the capability and the creativity will be able to elaborate. Most of the parents can enjoy following their child's lead, but others are simply not able to. The art therapist then intervenes to make the experience a good one for the parent. When the parent is able to follow the child's lead the child feels validated in his functioning capacity. The materials and the activity format assist the therapy as non-verbal factors, the therapist becomes the facilitator, and the group dynamics become positive. The art therapist must have the ability to see, hear, experience and tolerate her patients' visceral infantile art. If a parent requires more time from the art therapist in the group, to talk about their own childhood or personal issues, it is important to refer them to their own individual therapist, as soon as possible. In a clinical setting, this service is more easily available. In a community setting, a list of therapists should be compiled and made available to the parent. Some parents that I have worked with have continued individual work in art therapy, others chose to enroll in art courses, and others have gone back to further their studies.

Referrals to art therapy treatment may come from psychiatric outpatient services, social service agencies, developmental pediatrics, or other medical specialties, and often through parents, preschools, or day cares as well as pediatricians. Diagnosis at the time of assessment may include the full spectrum of infant and preschool disorders. Infants and their parents may be assigned to groups, and independent counseling of the parent or couple may be required for the work in art therapy to progress. The art therapist must be able to understand behavioral, developmental, and psychodynamic theory in planning and carrying out therapeutic interventions.

The therapist takes the role of facilitator in the art therapy intervention; this process helps to assess how a child interacts with the

parents and provides valuable information in understanding the child's behavior in the treatment group, in the day care, or at home. Another objective for the therapist is to understand the dyad's anxieties, aggressive impulses, inhibitions, and creativity. This intervention provides an important and successful treatment for children who have emotional, developmental, and behavioral difficulties that are often expressed as anxiety, depression, and somatic complaints, aggressive behavior or manifested as a learning problem.

Even earlier than 18 months, infant mark making has both form and function and involves physical and bodily aspects that can be communicative and revelatory. The process of physical engagement with the art material, even at a precursory stage of image making, becomes the focus for the dyadic interaction. The process becomes the symbol and the ritual that forms the basis of the art therapy attachment metaphor. The experience of joint art making through the dynamic process of dyad art therapy allows both the parent and the child to express inner feelings and in this manner they may resolve developmental core processes that may be affecting the parent–child interactions.

## The meaning of the art produced in dyad art therapy

To begin with, the art is composed literally by three artists: the child, the parent, and the art therapist who provides the container and the means to create within it. The content of the art production belongs to the two artist-clients, who join to create a work at an infantile level. The artwork therefore, contains elements from the unconscious, early infantile memories and developmental skills of both participants. One of the questions that I am frequently asked is: 'If this is art therapy how can you analyze or read the pictures produced?' In dyad art therapy, the art expression is a symbolic construction even when the art therapist creates interventions that allow for separate expressions. The clients who tell us a story, give the image a title, usually interpret the images. These are projective contributions of the parent and the child as well as those of the art therapist, who in her knowledge of art making and in art therapy studies, is bound to add her own projections without sharing them with the client. The structural features of the picture reveal whether the dyad is

comfortable enough in this manner of communicating to embellish each other's work, or aggressively destroy the other's marks. The page may have a subtle or obvious division; the picture may be two pictures on one piece of paper. The dyad may be unable to cooperate to make a joint picture, or they may decide to form and stay within their own unmarked boundaries. The limits created by the edge of the paper, no matter the size, may not be respected. The media may be destroyed in the amount of pressure imposed by stress or aggressive feelings or the lines may be so light that they literally disappear on the paper. The energy and vitality, the pleasure of the interaction and of creating is also observable in the joint artwork. Bruce Tobin states: 'If client pictures do indeed function along the lines of other forms of non-verbal communication, it means several things favorable for the art therapist trying to find meaning in them. First, as with body language, anything (every aspect of the picture) has potential communicative value... Second, as with body language, one cannot *not* communicate through art... Third, non-verbal messages are more likely to be expressed unconsciously than verbal messages (2002, p.5).

However, the process of the therapy is most telling and easily observable. The subtle interactions that occur between the parent and the child and how they interact in the group situation will give the therapist insight into the dyad's relationship. The aggressive pushing and pulling, punishing and threatening of the parent, who wants the materials for themselves, and are greedy about sharing. The child who, unused to interacting in this close proximity, rejects the parent's efforts. The temper tantrums, the willing cooperation, the spills, the crayon and marker breakages, all add information to the observant group art therapist. Also, although mentioned last, it really holds a first position, the history of the case, the presenting problems, and the child's birth history, are important to the art therapy treatment of the client.

As art therapists, we are often questioned about images made outside our own therapeutic sessions. As 'experts' we are asked to derive the meaning, more clearly than the meaning which is represented, and which may already be understood by the professional or parent questioning it. It is always difficult to refuse, but at the same time, we must be aware of our own projections. In the same manner, when viewing the art of your dyad

clients an approach taken by art therapist Bruce Tobin that may prove useful is that: 'the art therapist abandons the role of the expert making conclusive interpretations, and adopts an attitude of "enlightened ignorance", empowering the clients to interpret their own work, and encouraging them to take responsibility for the way they see their world' (2002, p.3). The making of the art, the process of the art making and the use of the media, as well as the interactions, will give the art therapist the knowledge required to assist her clients in strengthening the relationship.

## Transference and counter transference issues

In parent–child-dyad group art therapy, interactions and non-verbal communications are multiple; therefore, transference and counter transference issues are powerful. The art therapist is working with the parent–child-dyad, and the dyad will develop its own relationships with the art therapist; therefore, both parties may project onto the therapist. When working with a group of dyads, the dynamics may be overwhelming for a beginner who has not confronted his or her own issues, and who may not have appropriate knowledge of child psychology and development stages. I believe it is necessary to look at this therapeutic phenomenon.

Freud's definition of counter transference was described as the therapist's unconscious feelings, brought about by the patient's influences. Freud saw counter transference as a manifestation of the therapist's neurotic conflicts. However, contemporary thinking views counter transference as a vehicle that can facilitate understanding the patient's dynamics, and the dynamics of the art production. The client's transference projections and the art therapist's counter transference response become more complex in the process of art therapy, and even more so during parent–child-dyad art therapy. The therapist must be aware of her counter transference in their interactions with the parent and with the child. The art therapist must never become a 'better parent' than the child's parent, and she must not focus positive attention simply on the child nor simply on the artwork. Those therapists who have unresolved problems around their own early childhood experiences will have diffiiulties in distinguishing from their own, the mother's and the child's

feelings of emptiness that arise from anxieties, fears and emotional impoverishment. The therapist must be prepared to encounter primitive anxieties of helplessness, fear, and abandonment. The therapist may experience intense emotional reactions having more to do with the patient's premature intense and chaotic transference than with the therapist's skills. A supervisor can help sort this out.

The therapist's capacity to withstand the projected psychological stress and anxiety may, however, be related to specific problems of the therapist's past. The therapist's own early identifications may become reactivated as he or she is inundated by the patient-child primitive projections. The reemergence of anxiety connected with the early impulses, which may be directed at the patient, may cause a loss of ego boundaries. However, the therapist's emotional experience can be useful, because it may indicate the kind of fear and anxiety that the patient feels. The emotional exchanges between the infant or preschool child and the parent are present and observable, and may invoke strong counter transference reactions. During the course of the art therapy intervention aspects of the inner world of the parent and the child, which underlie their personalities and their relationship, may become manifested. The child's burgeoning personality, developmental abilities or delays and temperament, as well as the strengths and weaknesses of the containing capacities of the parent, will become evident. The therapist must be aware that spontaneous impulsive material may surface from within herself. This is where the structure of the session and of the activity and material choices will assist in the therapy. At all costs, chaotic discharge is to be avoided. Therefore, the art therapist must articulate the activity well, and be aware of her own feelings around containment.

I highly recommend to art therapists who are interested in parent–child-dyad work the writings of Arthur Robbins. I will refer to him to explain the dynamic experience of a parent–child-dyad group. In discussing the training of expressive therapists, Robbins reinforces my belief that the therapist must have sensitivity to the creative process and some direct experience of creative work, as well as undergoing personal psychotherapy. Direct experience of working with the infant or preschool population is essential. Robbins describes the group process as being a psychodynamic 'screen,' which contains all the projections of the self and

other. This screen will contain the projections of self and object representations; in other words, the past experiences of the participants as infants. Robbins' description of the group process aptly explains what is happening in the parent–child group therapy. The group may function as a psychodynamic screen for the externalization of self and object representations from the child, the parent, and the therapist. The structure of the group, the limits, the symbolic process, the materials and activity metaphors, form the containment for the 'fluctuating energy field of positive and negative vectors associated with projected and introjected identifications. The nature of this ever-changing field is communicated through non-verbal imagery, physical sensation, and affect mood states, as well as verbal metaphor. In treatment, this complex field of energy ebbs and flows, going through a process of gestalt reorganization. How the therapist responds to the spontaneous reorganization of his own inner field, of his own ever-changing gestalt, and how he utilizes his own conscious and preconscious symbolism is the very essence of his creative work' (Robbins 1986, p.19). Moreover, it is the very essence of his or her therapeutic work with parents and children. There is a need to use observational references for both the parent's unconscious artistic expressions and the child's responses. At this infant age, the mother-infant relation is considered visceral and to have an unconscious quality. The art therapist, while observing the dyadic and group interactions, should be keeping in mind that each party will bring something to the interactions. The parent–child communications are mutual interactions that may be verbal or non-verbal, and the group dynamics will have the same quality. Therapists who have not undergone personal therapy may find the stirring up of primitive material a threatening experience.

## Supervision and mentorship

As a placement and private practice supervisor, my most positive experiences have been with interns who had a firm grip on child developmental phases. Some had worked in day cares, others in infant clinical situations, and others as mothers. These same students were undergoing personal therapy or were willing to do so when counter

transference issues surfaced. However, I supervised students who developed unfounded fears around interactions with the patients, the team, and with me. These fears were directly related to their group work, but because of fear of failure, they remained unacknowledged. Other students have withdrawn into themselves during dyad group therapy, unable to interact verbally or otherwise, but feeling they were doing all they could. Other interns may use the dyad therapy for their own purposes, thus allowing chaotic discharge, while they had difficulty using messy materials. The sensory and kinesthetic aspects of the infantile art making produces a multiplicity of levels that may evolve in the therapy. The dyad, through the creative process may externalize their feelings. The art therapist may have a greater ability to understand their inter-personal relationship and its difficulties, with the help of counter transferential feelings. Supervision is more than making sure that the therapist is doing what she ought; it is in fact 'super' vision. Allowing a trained professional to view the session through the beginning therapist's experiences, and interpreting through experienced eyes. This is the ideal way to grow into the profession. It is also an opportunity for the supervisor to teach and mentor, and for the supervisee to become self-sufficient, and thus promote self-sufficiency and positive interaction in the group work.

# Conclusion

This book has focused on the use of the parent as partner in the treatment of their child and on the group intervention presented in diversified group settings. The combination of my many years of experience as a mother and as a day care giver, as well as my involvement with twins' parents' associations prepared me to work with parents and children. My experience as a multi-media artist gave me the freedom to try a variety of materials that would engage parents as well as children. My academic background in psychology and in art therapy, plus the clinical training and experience that I received helped me to observe, examine and adapt art therapy principles to working with the dyad. The experience I received in the department of child psychiatry familiarized me with the numerous physical and emotional problems that infants and preschoolers suffer and that parents must contend with though they may suffer their own difficulties. Finally, the knowledge and support that I received from the director of the department of psychiatry, and the direct supervision and guidance from the directors of the clinical teams, and the members of the multi-disciplinary teams that I worked on, contributed to the intervention outlined in this book.

The specific aims of the intervention are to include the parent as a direct participant in the child's treatment, permitting therapeutic input, and providing a window to monitor progress in the parent–child relationship. The factor that I had not expected in this intervention was that the artistic expression of the parent at the same level of their child's would have a therapeutic effect on the parent. This of course confirms art therapy theory that art expression is in itself therapeutic. The anecdotal material from the parents, during and after the sessions, began to confirm

this. That the treatment enhanced the parent's understanding of the developmental needs of their child, their own parenting skills, and promoted positive interactions between parent and child has been accepted by the professionals on the team. I realize that in order to provide scientific evidence of the healing that I was witnessing I will need to conduct this intervention within a research matrix. I hope in the near future to conduct research that will focus on the effects of dyad art therapy on the parent.

In the introduction, I have given you a sketch of who I am and where I come from since as a professional and as I parent, I like to have some knowledge of the person writing the book that I am about to read. A look at the basis of the infant psychiatry discipline provides you with the psychological perspective that I am drawing upon. Attachment theory field work is extensive, and seems to arrive at the conclusion that work with the parent and child is effective.

In Chapter 1, I have skimmed through the material and the contemporary work with parent and child, in psychotherapy, play therapy, and the expressive therapies. I could not begin to include all the work, which is in progress world wide, on this topic. How past parental conflicts impinge on relationships with children is addressed, along with the theories of art expression. This becomes the groundwork of this parent–child-dyad art therapy intervention. Why we include the parent as partner in therapy and what role they have to play in their child's therapy is addressed adequately and supported in Chapter 2. The format, process, application and integration of the intervention as far as I have applied it is described. I believe that this intervention is applicable in many therapeutic situations, and I leave it up to the art therapists in the field to add to this chapter.

In recent years, so much more research is going into observing brain development and the infant. Tools of research have been developed that allow the physician to look at the workings of the brain. Chapter 3 attempts to make the links between art making and the effects it has on our internal workings. The literature in the art therapy field on internal representations is vast, as this is the specialty of visual expression. Since it is not the mandate of this book to focus on this knowledge, I have chosen a few specific authors that illustrate my point. Throughout the

description of this intervention, I refer to Dr Stanley I. Greenspan and I recommend his books to therapists wishing to work with the infant and preschool population. His work on the functional emotional stages of the development of the child, and his intervention floor time, have inspired me, and have given me the tools necessary to articulate my work with children and parents.

In Chapter 4, I have illustrated the diversity of the intervention. I have shown how it has applications for children with a range of diagnoses, how it is helpful for parents with a variety of personal or family difficulties. I have shown how it is applicable in a variety of settings and age groups as well as how it is applicable with individual dyad work. I emphasize how it requires the art therapist to be familiar with the developmental stages of childhood and to make use of symbol and metaphor. This intervention utilizes a large variety of traditional media and household food materials to facilitate the interactions with the dyad. Through the examples of the activities and the material gleaned from years of working in the field, I have painted a picture for the therapist. The images of the artwork will help support this picture. The extent of the use of symbolic material, and the use of the metaphor are as broad as the creativity of the art therapist. Chapter 5 will help the therapist with some ideas of therapeutic activites, their symbolic meaning, and the promotion of social and emotional development.

Since the art therapy application of parent–child-dyad work is to my knowledge original work, I felt it necessary to add a chapter for the therapists. Therefore, I focus on the role and the experience of the art therapist quite thoroughly in Chapter 6. I address the effects and usage of transference and counter transference, and the necessity of the therapist to have ongoing personal therapy, experience with the preschool population, knowledge of the child's developmental stages, and supervision. I hope that this chapter will support the therapists undertaking this approach. Any mental health professional realizes that they are the facilitator; the client or patient does the work. Working with infants and parents is not simple or easy; each dyad comprises two people, with their own feelings and mental representations. Working with groups of dyads is more complex since the groups comprise six dyads, but 12 participants. All of these factors must be taken into consideration. I have

made extensive reference to the work of Arthur Robbins, to impress on the therapists the dynamics of the work and I recommend that his books be referred to. Personal therapy, supervision, and mentorship are not luxuries; they are the necessary tools of the art therapist. In the appendices, I have provided a list of assessment tools that help the mental health professional understand the dynamic situation of the client. The several art activities are included to help the therapists create their own interventions, first articulating them, for symbolic content, age-appropriate materials, and process. All the above information is important when working in a large group and assists the therapist in containing the group and in intervening appropriately.

The art therapist develops a relationship with the children and with the parents. Depending on the needs of each, the art therapy treatment provides input that will assure optimal progress. With a focus on artistic creations and age-appropriate cognitive and developmental techniques, the dyad art therapy interventions assist the children and the parents in changing existing difficulties and developing more positive interactions.

# References to Assessment Tools

It is extremely important for the art therapist to get as much information as possible when working with the infant and preschool population. A thorough family history and a birth history, including the pregnancy history, are useful especially when working with infants. Most of the assessments listed below may have to be administered by a psychologist.

There are many types of parent and teacher report measures available, as well as types of clinical assessments. I have included a condensed list of assessment tools that the art therapy professionals working in the infant and preschool field should be aware of. These measures give the therapist an overall picture of a variety of disruptive and acting-out, externalized behaviors. They also assist in measuring internalized behaviors such as anxiety problems and depression.

## Parent-Report Measures include:

Child Behavior Check List for ages 1½–5 (Achenback 1992).
Order from:

The University Associates in Psychiatry
1 South Prospect Street
Burlington
VT 05401-3456
USA

Parenting Stress Index (Abidin 1990)
Helps to identify families with high stress in relation to parenting and marital
practices.
Order from:

Psychology Press
39 Pearl Street
Brandon
VT 05733-1007
USA

## Teacher Report Measures (for the day care or kindergarten teacher) include:

Connors Assessment for Teachers.

Multi Health Systems Inc
65 Overlea
Blvd Suite 210
Toronto
Ontario M4H 1P1
Canada
Tel: 1-800-268-6011.

## Clinical Assessment Measures include:

The Crowell Assessment.

Judy A. Crowell
State University of New York
SUNY Stony Brook
New York 11794
USA

## Diagnostic Tools include:

DSM IV Diagnostic Criteria.

American Psychiatric Association
1400 K Street NW
Washington DC
USA

'Diagnostic Classification of Mental Health and Developmental Disorders of Infancy and Early Childhood in Assessment and Treatment Planning.'

Zero to Three National Center for Infants, Toddlers, and Families
734 15th Street NW
Suite 1000
Washington DC
20005-1013
USA

These are but a few of the assessment tools available.

# Dyad Art Therapy Interventions Equipment and Material Presentations

The activities described in Chapter 5 were developed for parent–child-dyad work with the early childhood population and have been applied therapeutically. The parent–child-dyad art therapy intervention is designed to help the parent slow down to the developmental level of the child. Here is a list of the equipment and materials that are used in this book.

## The equipment

- Child height tables and chairs
- Aprons: adult and child size
- Variety of broad based containers, not easy to tip or spill
- Variety of Styrofoam trays
- Variety of paint brushes, sponges, washcloths, towels, paper towels
- Variety of paper: newsprint, finger paint paper, self-adhesive (contact) paper, colored acetate, sandpaper and other textured and metallic paper, aluminum foil
- Roll of 3' to 4' wide craft paper to cover the table
- Variety of tapes: masking, clear, etc.
- 1½ Cup flour scoops; 14 wooden spoons
- Large wide mouth, low, mixing bowl
- Cookie cutter shapes, small rolling pins, Popsicle sticks for knives

- Variety of shakable containers for sparkles, jelly powder, spice, powder tempera paint
- Clay working tools
- Scissors (child size)

The materials are presented in an inviting fashion, which indicate without explanation what the activity might be.

## The materials

The materials below are listed in the various activities.

- One piece of paper for each dyad to work on together, securely taped to the table with masking tape.
- Cafeteria type trays may be used to help delineate space and create boundaries, securely taped to the table.
- When covering the whole table, secure the paper under the table.
- Paint is presented in small quantities in small containers:
  - Finger paint – 1 large tbs in a small plastic container or on a plastic jar cover. Maximum 4 colors per dyad.
  - Liquid paint – approx. 1oz in a small holed container (like shampoo bottles) for easy pouring and holding (several of which can be shared by the group).
- Shakers: Salt shakers or empty spice bottles. Some holes can be covered over with tape on the inside of the cover which allows the child to shake out sparkles, dry tempera paint, jelly powder, flour, spice, etc. easily but not too rapidly.
- Water: is provided in small amounts in low, wide-mouthed containers. Plastic jar covers are usually ideal for this.
- Crayons, markers, etc.: 1 box for each dyad or 4 crayons on a Styrofoam™ tray, same colors for the whole group.
- Collage materials: presented in a pile in the center of the table. Colored, textured paper acetate is ripped into small pieces.
- Glue: presented in small, low, wide-mouthed containers, so the child may dip the paper in.

- Self-adhesive (contact) paper: placed adhesive side up on the paper that is taped to the table.

- Self-adhesive stickers.

- Sculpture uses materials such as clay, modeling clay and play-dough presented on the taped paper for each dyad:

  - Clay – 2 balls of clay for each dyad.

  - Play-dough – make it as a group.

  - Box Sculptures – a variety of boxes collected from the participants and fixed together using tape and plaster bandage material.

*Figure 33: Car painting.*

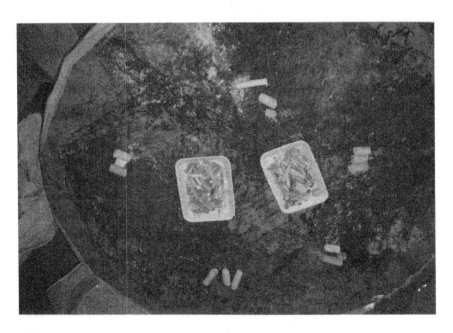

*Figure 33a: Drawing a map of where we live.*

*Figure 33b: Bubble blowing and drawing a wish in the bubble spot on the paper with watercolor crayons.*

*Figure 33c: Working within a container.*

# References

Ainsworth, M.D.S., Blehar, M.C., Waters, E. and Wall, S. (1978) *Patterns of Attachment. A Psychological Study of the Strange Situation.* Hillsdale, NJ: Eribaum.

Arnheim, R. (1967) *Towards a Psychology of Art.* Berkeley: University of California.

Begley, S. (1997) 'How to Build a Baby's Brain.' In *Newsweek*, Special Edition, 'Your Child.'

Ben Aeron, M., Harel, J., Kaplan, H, and Patt, R. (2001) Mother–Child and Father–Child Psychotherapy: A Manual for the Treatment of Relational Disturbances in Childhood. London and Philadelphia: Whurr.

Bezonsky, R., Gutman, F. and Proulx, L. (1989) 'A group for divorced mothers with children.' Unpublished paper presented at the 10th Annual Symposium of Social Work with Groups. Innovative Approaches to Group Work. Oct. 1989, Montreal.

Brazelton, T., Koslowski, B. and Main, N. (1974) 'The origins of reciprocity: the early mother–infant interaction.' In M. Lewis and L. Rosenblum (eds) *The Effect of the Infant on its Caregiver.* New York: John Wiley.

Bowlby, J. (1969) *Attachment and Loss: Attachment.* New York: Basic Books.

Canfield, J., Schopflocher, C., Bass, R. and Proulx, L. (1996) 'An early school-based integrative therapeutic kindergarten program for disruptive behaviour-disordered and developmentally delayed children. Westmount Park school-kindergarten project.' Poster presentation at the Canadian Academy of Child Psychiatry, Quebec.

Canfield, J., Bass, R. and Proulx, L. (1999) 'An early school-based integrative therapeutic kindergarten program for disruptive behaviour-disordered and developmentally delayed children.' Unpublished paper presented at the Canadian Conference on Educating Students with Behaviour Disorders. Université Laval, Ste Foy, Quebec, Quebec.

Chapman L., Morabito, D., Ladakakos, C., Schreler, H. and Knudson, M.M. (2001) 'The effectiveness of art therapy interventions in reducintg post traumatic stress disorder (PTSD) symptoms in pediatric trauma patients.' *Journal of the American Art Therapy Association, 18, 2,* 100–104.

Cirlot, J. G. *A Dictionary of Symbols.* London: Routledge and Kegan Paul.

Cooper, J.C. (1978) *An Illustrated Encyclopaedia of Traditional Symbols.* London: Thames and Hudson.

Cramer, B., Robert-Tissot, C., Stern, D., *et al.* (1990) 'Outcome of a situation in brief mother–infant psychotherapy: A preliminary report.' *Infant Mental Health Journal, 11,* 278–300.

Crowell, J. and Feldman, S. (1988) 'The effects of mother's internal working models of relationships and children's behavioral and developmental status on mother–child interactions.' *Child Development, 59,* 1273–1285.

Dongier, S., Lobato, H. and Laplante, S. (1991) 'Approches en psychiatrie du Nourrisson. Le programme de l'Hopital Doublas pour les jeunes enfants et leurs parents.' P.R.I.S.M.E. *Psychiatrie Recherche et Intervention en Sante Mentale de l'Enfant, Automne 1991, 7,* 1.

Di Leo, J.H. (1970) *Young Children and Their Drawings.* New York: Brunner/Mazel.

Di Leo, J.H. (1973) *Children's Drawings as Diagnostic Aids.* New York: Brunner/ Mazel.

Emde, R.N. and Sameroff, A.J. (1989) 'Understanding early relationship disturbances.' In A.J. Sameroff and R.N. Emde (eds) *Relationship Disturbances in Early Childhood.* New York: Basic Books.

Estes, C.P. (1996) *Women Who Run with the Wolves.* Paris: Ed. Grasset.

Fonagy, P., Steele, M., Moran, K.G., Steele, H. and Higgitt, A. (1993) 'Measuring the ghost in the nursery: an empirical study of the relation between parents' mental representations of childhood experiences and their infants' security of attachment.' *Journal of the American Psychoanalytic Association 41,* 957–989.

Fraiberg, S. (1980) 'Ghosts in the Nursery: A psychoanalytic approach to the problems of impaired infant–mother relationships.' *Clinical Studies in Infant Mental Health: The First Year of Life.* New York: Basic Books.

Gillespie, J. (1994) *The Projective Use of Mother and Child Drawings. A Manual for Clinicians.* New York: Brunner/Mazel.

Gonick, R.S. and Gold, M. (1992) 'Fragile attachments: expressive arts therapy with children in foster care.' *The Arts in Psychotherapy, 18,* 433–440.

Greenspan, S.I. (1992) *Infancy and Early Childhood: The Practice of Clinical Assessment and Emotional Developmental Challenges.* Madison: International Universities Press.

Greenspan, S.I. (1981) *Psychopathology and Adaptation in Infancy and Early Childhood.* New York: International Universities Press.

Grözinger, W. (1955) *Scribbling, Drawing, Painting.* Praeger: New York.

Harvey, S. and Kelly, C. (1993) 'Evaluation of the quality of parent–child relationships: a longitudinal case study.' *The Arts in Psychotherapy, 20,* 387–395.

Kaiser, D.H. (1996) 'Indications of attachment security in a drawing task.' *The Arts in Psychotherapy 23,* 4, 333–340.

Kernberg, P. (1991) *Fathers on Fathering.* Video tape. Cornell Medical Center, New York Hospital.

Kellogg, R. (1970) *Analyzing Children's Art.* Pablo Alto: Mayfield.

Kramer, E. (1958) *Art Therapy in Children's Community. A Study of the Function of Art Therapy in the Treatment Program of Wiltwick School for Boys*. New York: Schoken Books.

Kramer, E. (1979) *Childhood and Art Therapy. Notes on Theory and Application*. In collaboration with Laurie Wilson. New York: Schocken Books.

Lachman, M., Cohn Stuntz, E. and Jones, N. (1975) 'Art therapy in psychotherapy of a mother and her son.' *American Journal of Art Therapy, July, 14*, 105–116.

Lieberman, A. and Pawl, J.H. (1988) *Clinical Applications of Attachment Theory*. In J. Belsky and T. Nezworski (eds) Clinical Implications of Attachment. Erlbaum Assoc., Hillsdale, NJ.

Landgarten, H.B. (1981) *Clinical Art Therapy. A Comprehensive Guide*. New York: Brunner/Mazel.

Levick, M.F. (1983) *They Could Not Talk and So They Drew. Children's Styles of Coping and Thinking*. Springfield: Charles C. Thomas.

Lowenfeld, V. (1987) 'Therapeutic aspects of art education.' *The American Journal of Art Therapy, 25*, 111–117.

Mahler, M.S., Pine, F. and Bergman, A. (1975) *The Psychological Birth of the Human Infant. Symbiosis and Individuation*. New York: Basic Books.

Main, M., Kaplan, N. and Cassidy, J. (1985) 'Security in infancy, childhood and adulthood: a move to the level of representation.' In I. Bretherton and E. Waters (eds) *Growing Points of Attachment Theory and Research*. Monographs of the Society for Research in Child Development, 50.

Malchiodi, C.A. (1998) *Understanding Children's Drawings*. New York and London: The Guilford Press.

McDonough, S.C. (1995) 'Interaction guidance: an approach for difficult-to-engage families.' In C. Zeanah *Handbook of Infant Mental Health, 2nd edn*.

Meriam Webster Ninth Collegiate Dictionary (1983) Thomas Allen and Son Ltd., Markham, Ont.

Minde, K. and Minde, R. (1982) 'Parenting and the development of children.' *Handbook of Child and Adolescent Psychiatry, 7, 14*, 265–283.

Minde, K. and Minde, R. (1981) 'Psychiatric intervention in infancy.' In *Journal of Child Psychiatry, 20*, 27–28.

Minde, K. and Tidmarsh, L. (1997) 'The changing practices of an infant psychiatry program: the McGill experience.' *Infant Mental Health Journal, 18*, 2, 135–144. Michigan Association for Infant Mental Health.

Muir, E. (1992) 'Watching, waiting, and wondering: applying psychoanalytic principles to mother–infant intervention.' *Infant Mental Health Journal, 13*, 4, 319–328.

Naumburg, M. (1966) *Dynamically Oriented Art Therapy: Its Principles and Practices*. New York: Grune and Stratton.

Perry, B. (1997) 'The Brain.' In S. Begley *How to Build a Baby's Brain, Newsweek*, Special Edition, Your Child, 28–32.

Proulx, L., Aspler, L. and Canfield, J. (2001) 'Parent–child-dyad group art therapy: adjunct therapy within a preschool day treatment program.' Poster presentation at the Canadian Academy of Child Psychiatry, Montreal.

Proulx, L. and Minde, K. (1995) 'Une experience de groupe pour pères et enfants.'P.R.I.S.M.E. *Psychiatrie, Recherche et Intervention en Santé Mentale de l'Enfant, 5, 2–3,* 191 –200.

Proulx, L. and Tidmarsh, L. (1997) 'Group intervention for younger children with disruptive behaviour. Parent–child dyad art therapy intervention.' Unpublished paper presented at the AATQ 1997 Conference, Lennoxville, Qc, at the Douglas Hospital, Montreal Qc.

Proulx, L. and Tidmarsh, L. (1998) 'Disposition or opposition? Understanding an anxious and difficult child in a cultural context.' Unpublished paper presented at the Zero to Three 13th National Training Institute Conference. Washington, D.C.

Pruett, K. (1985) 'Children of the father mother: infants of primary nurturing fathers.' In J.D. Call, E. Galenson and R.L. Tyson (eds) *Frontiers of Infant Psychiatry, 2,* 375–381. New York: Basic Books.

Resnick, J., Resnick, M.B., Packer, A.B. and Wilson, J. (1980) 'Fathering classes: a psycho/educational model.' In T.M. Skovholt *et al.* (eds) *Counselling Men.* Monterey: Brooks/Cole Publishers.

Robbins, A. (1986) *Expressive Therapy. A Creative Arts Approach to Depth Oriented Treatment.* (With contributors) New York: Human Sciences Press.

Roy, N. (1999) 'Le développement de groupes d'art thérapie pour les mères en difficultés présentant des problèmes d'attachement.' MA thesis. Institut de Formation Professionnelle en Psychothérapie par l'Art.

Rubin, J.A. (1976) *Children, art and growing … In diagnosis, therapy and education.* Health Journal; Michigan Association for Infant Mental Health University of Pittsburgh, Xerox University Microfilm, Michigan.

Rubin, J.A. (1984) *Child Art Therapy. Understanding and Helping Children Grow through Art.* New York: Van Nostrand Reinhold.

Slade, A. (1996) 'Representation, symbolization, and affect regulation in the concomitant treatment of a mother and child: attachment theory and child psychotherapy.' Paper presented to the American Psychological Association, New York.

Stern, D. (1978) 'Early infant behavior seen undergoing intensive study.' *Clinical Psychiatric News, August, 1978.*

Tobin, B. (2002) 'What does the picture mean? Towards a theory of interpretation of client art.' *The Canadian Art Therapy Association Journal, 14,* 2.

Waters, E. and Crowell, J. (1999) 'Attachment theory and research.' Presented at the McGill Infant Mental Health Group 7th Annual Teaching Day Montreal.

Wesner, D., Dowling, J. and Johnson, F. (1982) 'What is maternal-infant intervention? The role of infant psychotherapy.' *Psychiatry, 45, November 1982,* 307–314.

Winnicott, W.D. (1951) 'Transitional objects and transitional phenomena.' In D.W. Winnicott *Collected Papers. Through Paediatrics to Psycho-Analysis.* New York: Basic Books.

Winnicott, W.D. (1971) *Playing and Reality.* London: Tavistock.

Wix, L. (1997) 'Picturing relationship: An image-focussed case study of a daughter and her mother.' *American Journal of Art Therapy, February, 35,* 74–82.

Zeanah, C.H., Boris, N.W. and Scheerings, M.S. (1997) 'Psychopathology in infancy.' *Journal of Child Psychology/Psychiatry, 38,* 1, 81–99. Cambridge University Press.

Zeanah, C.H., Boris, N.W., Heller, S.S., Hinshaw-Guselier, S., Larrieu, J.A., Lewis, M., Palomino, R., Robaris, M. and Valliere, J. (1997) 'Relationship assessment in infant mental health.' *Infant Mental Health Journal, 18,* 2, 182–197.

# Subject Index

abstract art
  collage 118–19
  painting 130–1
abuse 25, 51
  effects on brain 55
Adlerian Center 15
adopted children 107
aggressive behaviour 18, 46, 60, 74, 80,
  89, 92, 94, 97, 108, 109, 111, 164
Anna Freud Center, London 44
anxiety 46, 55, 164, 167
aquarium sculpture 153–4
  group dyad example 96–8
art materials 177–9
  built-in limits 27–8, 39, 61–2
  importance of therapist's knowledge
    39
  non-traditional 17, 38–9, 69–70
  presentation 17, 73, 117
  symbolic meaning 68–72
art therapy
  contemporary parent–child work
    24–6
  and emotional development 57–67
  and internal representation 56–7,
    171
artwork *see* child art expression; dyad
  artwork
assessment 22, 24–5, 32, 38, 45
  tools 174–6
attachment 61
  art therapy metaphor 68–115
  assessment 24–5
  effects of mother's representation
    55–6
  parental conflicts 22, 27
  problems 61, 92, 100–2, 108
  theory and fieldwork 20–1, 171
'attention and engagement' stage 59–60
attunements 25
autism spectrum disorders 19, 89, 92

behavioural disorders 26, 46, 47, 59,
  80, 164
  *see also* aggressive behaviour;
    impulsive behaviour

bi-manual drawing 30, 57
biological characteristics 26
'bird's nest drawing' 25
box sculpture 151–2
  group dyad example 88–92
boxes and trays, symbolic aspects 70
brain development 54–6, 171
'breath patterns' 57

car painting 136
causality 54
cause and effect stage 60–2
chalk
  on black construction paper 143
  symbolic aspects 70
  on wet sandpaper 142
chaotic discharge 27–8, 32, 39, 62, 73,
  167, 169
Chapman Art Therapy Treatment
  Intervention (CATI) 56
child art expression, theories 29–33,
  171
clay, symbolic aspects 71, 156
clay drawing 145
clay
  sculpture 156
  animal families, group dyad example
    92–6
  battlefield, individual dyad example
    111–12
clothes making and suitcases 148–50
collage 118–29
  group dyad example 75–6
  individual dyad example 108–9
communication *see* engagement and
  communication; non-verbal
  communication
  two-way communication
cornstarch, symbolic aspects 69
cortisol 55
*Counseling Man* 42
Crowell relationship procedure 24, 45

depression
  parental 18, 26, 45, 75, 100
developmental disorders 18–19, 26, 29,
  46, 47, 108, 116, 117, 147, 164
*Dictionary of Symbols*, A (Cirlot) 69
distal and proximal contact 40–1, 64
divorce 18, 51, 112
divorced mothers group 49–50

# Author Index